Mothers and Daughters
Together

Mothers
and Daughters
Together

We Can Work It Out

Kay Strom

and

Lisa Strom

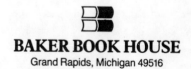

BAKER BOOK HOUSE

Grand Rapids, Michigan 49516

ISBN: 0-8010-8289-7

Printed in the United States of America

Contents

• Part Five: All in the Family •

• Part Six: Building Sound Values •

Introduction

When a girl reaches adolescence, she and her mom can expect:

 A. Nothing but trouble

 B. That the happy days are gone forever

 C. Some problems but many joys

Which answer did you choose? *A* or *B*? If so, you're not alone. Many parents, especially mothers, dread seeing their children enter the teen years. "Nothing but trouble," they sigh, with a media-inspired pessimism. Their daughters also expect the worst: "Mom doesn't understand me. She treats me like a baby!" But we hope you chose *C*. It's true, you know—even though right now you may already be so deep in the problems that you can't see the joys.

Most adults in our society expect life during adolescence to be a tough time, crisscrossed with friction and

turmoil. Most teenagers agree, since it is certainly a time of confused feelings—sexually, emotionally, in relationships with peers and parents, and in solidifying values and beliefs. While a teenager may look and feel mature and want to be treated as an adult, at times the child inside fights his or her way out and causes many frustrations and ambivalent emotions. Teenagers fight desperately for "independence," yet too much freedom scares them, since they are not ready for complete decision-making responsibility. They resent feeling overprotected, yet they need and want attention from their parents for the comforting security this signifies.

It is only when our daughters become teenagers that many of us moms suddenly realize we must deal with a whole new set of parental circumstances, some vaguely expected, others startling surprises. Suddenly our "little girl" hates the clothes we think are perfect for her and admires strange fashion trends, the propriety of which seems questionable to us. When we want to meet her friends, she becomes defensive and takes our interest as a personal affront. No longer are parental opinions and suggestions welcome. Our ideas have been replaced by the ideas of our daughter's peer group, many of whom we will never know except as a voice on the phone asking for her.

It does not come easily for us to allow our daughters—who in our eyes are so young and dependent—to become separate people who can make their own decisions. But then, it's no simple task for the daughters either. Not only do they have to adjust to the many changes going on in their bodies and experiences, but they must also deal with us on a new level.

While the focus of this book is on mothers and daughters, both are influenced by Dad. It is important to get his input, to ask his advice and insights when problems arise. Many times he is the one best suited to offer the needed perspective to defuse an issue or to act as a moderator.

As in any strong relationship, communication is the key to how well we moms and daughters make it through these years. Unless we "talk it out" (which means doing a lot of listening, too), how can we hope to understand each other on any issue? And unless we spend these crucial years building bridges instead of walls, how can we ever hope to emerge from this period of conflict and ruffled feelings into lifelong friendship? So let's begin here at the beginning—with communication.

Many mothers think they are communicating with their kids when they are really lecturing and scolding. Their daughters react to this one-way conversation by shutting up, both vocally and emotionally. When moms press, their daughters accuse them of prying and insensitivity. So, moms, let's take the initiative and see if we really are communicating through a give-and-take dialogue. Perhaps these questions can open up some channels, especially if you are able to share their insights with your daughter.

1. *When the two of you talk, do you each give your full attention to the other?* Your exchanges will be more satisfying and productive if you put aside your book or homework, or turn off the television. Let the other know that what she is saying is important to you.

2. *Do you listen calmly and let the other finish what she wants to say, even when you disagree strongly?* It's

important that you concentrate on hearing *her* point of view. And, teen, if you expect your mom to tune in to you, you must be willing to open up. Mom, be careful not to start lecturing. Stick with a two-sided discussion. It's easier to listen when you know the other is willing to hear what you have to say.

3. *Do you both use courteous tones of voice when you talk to each other?* Respect encourages respect, and it starts with the way you speak. Try talking to each other as you talk to your friends.

4. *Are you able to resist the urge to make quick judgments?* No one wants to confide in someone who has a critical stance. You don't have to agree, but if you truly want to communicate, it's vital that each of you tries to understand the other's viewpoint. It isn't easy to put yourself in another's place, especially when emotions are high and conflicting pressures make the choices hard. But don't give up. The results will be well worth the effort.

5. *Is the door open on every subject?* Between the two of you, no topic should be off limits if a mutual sense of trust and confidentiality has been established.

6. *Are you careful never to belittle or laugh at each other?* Those jokes and little asides may not seem such a big deal to the one using them, but ridicule can cause deep wounds that will be remembered for a long, long time.

7. *Do you let the other person express her hopes, values, ideas, and feelings, even if they are miles away from your own?* Let's face it: we moms do tend to be set in our ways, to want things done as *we* have always done them. And teens often test their ideas on their parents just to gain attention or see what reaction they

will have. But if we are really to communicate, we must be willing to listen to and acknowledge each other's opinions, even when those opinions frustrate or alarm us. When it's your turn, you can give *your* viewpoint.

8. *Do you say nice things to each other?* Too often, moms criticize a daughter's friends, styles, and musical taste. Teens tend to complain that their mothers are hopelessly out of touch with reality. Remember, you both need to be accepted, appreciated, and complimented by the other as a total person with unique qualities.

9. *Can you together smooth out the rough places and move toward solutions with which you both can live?* You can do this formally—perhaps by holding regularly scheduled discussion times. Or you can do this casually—perhaps agreeing to stop and listen when a specially agreed upon signal is given.

10. *Have you overlooked Dad?* In a healthy family, parents work together to establish family guidelines and standards of acceptable behavior. Mom, let your daughter know that you and Dad are co-managers of the family team.

However well the two of you communicate, and however healthy your relationship, some conflict is inevitable. The question is not, "*Will* we ever clash?" but "*When* we differ, how will we handle it?"

When a problem arises in a family, it's important that all concerned do their best to bring it to an end as quickly yet painlessly as possible. Accomplishing this through a display of parental power or adolescent temper will only make matters worse. The situation must be worked through, and this almost always means com-

promise. Talk but also listen, remembering to let go of your anger or hurt. Forget trying to get back at the other party. Perhaps it will help to remember that neither of you deliberately set out to upset or hurt the other.

Understand, too, that since few disagreements and misunderstandings are entirely one person's fault, there's a better way of solving problems than trying to place the blame. It is usually possible to find an answer you can both live with. Below are some suggestions for achieving better negotiations:

Begin by setting down some absolutes. Are there certain areas that will not be negotiable? Certain things that are absolutely forbidden, no matter what? If so, you should both understand what they are. One word of caution, Mom: If you state an ultimatum, be prepared to carry through with all it implies. After a few empty threats, young people tend to pay little attention to future counsel and warnings. Before you say, "If you ever touch drugs, I'll throw you out of this house," ask yourself if you are ready to do just that.

When there is a conflict, be sure you both understand exactly what the issue is. You may each be seeing a situation from a totally different point of view. That's all right. But even if you agree on nothing else, agree on what it is you are talking about. Some moms and daughters tend to assume they will automatically disagree with each other. It may surprise you to find that, after hearing each other out, your opinions are often quite similar.

Listen—*really* listen—to what the other has to say. Make it a rule not to respond until you have listened carefully and are sure you understand her position. Not only is this polite; it is effective. Half-hearted listening

tells the other person either that what you are doing at the moment is more important than working out the difficulty or that your mind is already made up on the issue. It will be a whole lot easier to listen effectively if you are careful to choose an appropriate time to talk about the problem. If one of you is in a hurry, especially tired, or in a bad mood, chances are you will end up arguing.

If you cannot agree at the first try, understand that you cannot continue to push against each other forever. The longer you persist, the further apart you will drift and the less probable is a resolution. Unless each of you gives a little, there can be no compromise. Remember, the problem almost certainly has two sides. Be willing to look at both and admit what you have contributed to the conflict. At the end of the negotiation, be willing to abide by the agreed-upon solution.

It is hardly realistic to expect complete agreement between a mother and her teenage daughter. Though it can be painfully difficult to live through this stressful period of arguing and bitter silence and even open conflict, disagreements need not destroy your relationship. When both of you make an honest effort each day to communicate and respect the other, the teenage years can be exciting ones for both of you. There will, indeed, be problems—but how sweet the shared joys will be!

What Price Freedom?

1

Tolling the Curfew Bell

• **Mother...** •

As my husband and I left for church one evening, we called back to the kids, "We'll be home by eight." The program lasted longer than we expected, and then, as we were leaving, we ran into some friends we hadn't seen for some time and got to talking. When we finally arrived home, it was after ten. Lisa and her brother were waiting for us at the door. One glance told us they were upset. "Do you know what time it is?" Lisa demanded. "We were so worried! Where have you been?" Lamely we explained that we got to talking and forgot about the time. "That's no excuse," she scolded. "You could at least have called!"

The scenario was painfully familiar. We had been through it several times before. This time, however,

the exasperated words of reproach were coming from my daughter instead of me.

For parents of teenagers, maintaining curfews comes with the territory. It is important that we know when to expect our young people home. Since we are accountable for their well-being, we also have the responsibility to set reasonable standards for when they are to be home at night. And our children are responsible to the other members of the family to adhere to the promise implied in a curfew, just as my husband and I were responsible to Lisa and her brother to keep them informed.

Unless our young people know exactly what the boundaries are, how can they be expected to stay within them? They want and need specific guidelines from us. Yet, when the limits are set, kids will inevitably test them to see if they will hold—especially with rules as cut-and-dried as curfews.

There is more than one way of establishing time boundaries. Some families set a blanket rule: "You must be in by ten on school nights, eleven-thirty on weekends." Others choose to be more flexible: "If you're going to a movie, be in by ten-thirty—or nine-thirty after a football game." Another way to handle this is to ask your teen daughter what time she intends to be in and then hold her accountable to her own deadline, assuming, of course, that her "intention" is not way out of line with her maturity.

When Lisa was thirteen, we carefully defined her hours and monitored her adherence to them. As she proved she could stay within those limits, we gradually rewarded her with more lenient requirements. That

way, Lisa learned the practical results of acting in a responsible manner while her father and I enjoyed her growing dependability. The result was that from the beginning we all had a feeling of working with, not against, each other.

It is a rare teen who doesn't miss her curfew now and then. Unexpected things do happen—tires go flat, traffic ties up, misunderstandings occur. If you are reasonable in handling your daughter's rare curfew misses, she will be much more likely to cooperate with the rules you have set. That's not to say that occasional lapses should be ignored. They should always be noted as such. In fact, the way a teenager accepts the responsibility for (and consequences of) missing a curfew says a lot about her level of maturity.

But what if your daughter continually oversteps her curfew limits? Combining discipline *now* with a promised reward *to come* will likely solve the problem. You might say something like, "Again and again I have talked to you about coming in late. I had planned to extend your curfew until eleven, but because you haven't been responsible about meeting your ten-thirty deadline, I'm going to cut it back to ten for two months. If you can stick to that curfew, it will go back to ten-thirty. If you continue to be responsible for another two months, we'll talk about extending your deadline." If she continues to be irresponsible, a more severe punishment is probably in order, such as being grounded from certain activities.

Rather than think of Lisa's curfew as a method of "control," I prefer to approach it as a means of teaching her responsibility and accountability to herself, to her parents, and to the rest of the family.

• Daughter... •

A curfew was not an easy thing for me to accept. Some of the kids I knew had them, but others didn't. Having to be in earlier than my friends could really be embarrassing. It didn't seem fair.

I can think of many times when *my* curfew caused problems for others who didn't have one. Several times friends wanted us all to go to a late movie, but I couldn't because I had to be in too early. Other times everyone else wanted to stop and get a hamburger and fries on the way home from a game or party, but it would have made me late. My friends didn't like having to take me home at 10:30 when they didn't have to be in that early.

I complained at home—maybe a little too much! But I did get my point across. My parents and I finally agreed on a better curfew system, one that was more flexible. My time to be in would depend upon the activity. An 8:00 P.M. movie would call for me to be home by 10:30. If I went out to dinner, I was to be home by 9:00. For a formal at school, the curfew might be set for 12:00 or 12:30. If something happened that would make me late, or if we changed our plans for the evening, I was to telephone. That plan was good for both my parents and myself. They knew where I was going and when I would be home, and I had the flexibility I needed.

When we teenagers are given curfews, whether or not we agree with them, we need to be responsible about keeping them. I had to learn this the hard way! But once I started showing my parents I could be de-

pended on to be home when I said I would, they started
trusting me and giving me more freedom.

• We Can Work It Out •

As in so many other areas of our mother-daughter
relationship, Lisa and I found that her curfew worked
more smoothly and satisfactorily for both of us when
she helped set the boundaries, knew exactly what was
expected of her, and understood the consequences of
breaking the rules. Working this out together benefited
us on other levels as well. Her father took the oppor-
tunity to let her know that the matter of accountability
went far beyond the mere setting of rules. Because we
were responsible for her well-being and safety, it was
important that we know where she was and approx-
imately when to expect her home. It also provided an
excellent opportunity for all of us to demonstrate our
love, respect, and trust for each other.

When Lisa was a young teen, her hours were definite
and fairly rigid. By the time she was fifteen, at her
request, we agreed that a more flexible curfew was in
order. Within a year we decided she had proven her
dependability and should generally be able to set her
own curfew, with the stipulation that she was to tele-
phone if she would be later than expected. This has
worked well for us, but it certainly is not the only way
to determine a curfew. Nor is it necessarily the best for
your situation. Sit down together and work out a sys-

tem of your own. Keep in mind that flexibility can go a long way toward easing the strains between you and your adolescent.

Two last thoughts for you parents: First, be careful to examine your motives for the rules upon which you insist. Are they strictly for your own convenience? Are they holdovers from the possibly unreasonable rules that were imposed upon you? Some of your ideas may need to be revised. Second, be careful not to watch so intently for violations that you fail to notice your daughter's usually responsible behavior and cooperative attitude. Recognize and reward them.

2

"You Call *That* Music?"

• Mother... •

When the youth minister announced in our parents' meeting that we would be seeing a video on the popular music our teens listen to, the whole group groaned. "Music?" one father exclaimed. "You call that noise *music?*"

So what's new? My parents said the same thing about the music I liked as a teenager. Yours probably did, too. We listened anyway.

Earlier in the evening, the youth minister had told us about a survey in which teenagers were asked where they turn for help and comfort when they are hurting. "Consulting with a youth minister" and "talking to the family dog" tied for fiftieth place. "Dad" rated forty-second. "Mom" fared better; she ranked nineteenth. What was number one? Listening to music.

"It's not the beat that bothers me," stated an obviously upset mother. "It's the words of so many of those songs." Many of the rest of us nodded our agreement. Some rock groups are notorious for their themes of sex, materialism, drugs, violence, and even satanism. A few parents tried to pass off these concerns by assuring the rest of us that the words don't really matter; no one can understand them anyway. We didn't buy that excuse. Not only do our kids understand them, they memorize and sing them.

Mom, when your daughter talks about the latest popular group, do you say, "Who's that?" with implied indifference if not disapproval, or just plain ignorance? Most parents do. Yet, just as it is important that we know what our daughters are hearing, it is also important that *they* know we are interested in what matters to them. Listening to their music will help us accomplish both aims. I know, I know—you don't *like* that music. Listen anyway. Some may not be as bad as you thought. You may even hear something you actually enjoy. It may help to remember that some of those very songs, played in their "easy listening" versions, will likely be soothing your nerves five years from now as you sit in the dentist's chair.

Teenagers appreciate it when their parents find value in what they do or at least show respect for their thoughts and ideas. Through listening with Lisa to her music, I have a chance to understand her enjoyment of some songs, to learn truly to like others, and to express my reasons for disliking the remainder. This shared experience allows me a chance to offer a Christian perspective to the distorted philosophy of life depicted

in some of the lyrics I hear. And, because I listen, I know enough about the music and the performers to talk about them somewhat intelligently.

If you aren't used to listening to your daughter's favorite music—maybe you've even done your share of criticizing—it may be tough to start now. She has already become used to tuning you out (and vice versa). The first time you say, "I want to listen to some of your tapes," she is likely to eye you suspiciously and answer, "Forget it." You may find it just as difficult to convince her that you truly want to understand her world as she finds it not to see you as an intruder.

But "difficult" doesn't mean impossible. Instead of saying, "Must you listen to that trash?" try, "Let me listen with you." By taking advantage of repeated opportunities, you should be able to prove your genuine interest. If you find the music or words offensive, tell her why. Is it merely because it's so different from the music you listened to when you were a teenager? Is the beat disturbing? Is it the lyrics that are objectionable? By listening, you earn the right to have an opinion, even if you don't convince your daughter.

This idea of listening before giving an opinion was suggested at our parents' meeting. One frustrated mother of a sixteen-year-old insisted she had tried the approach and found it didn't work. "And not only once," she added. "I tried it *twice!*" Of course, two tries are not nearly enough, especially when the girl is sixteen and the mother has heretofore been unsympathetic to her interests. By then a mom has already lost her daughter's confidence. It takes a good deal of time and patience to regain a trust that has already faltered.

What about Christian rock artists? Don't be too quick to criticize them. Though their music may not be any more enjoyable to you than that of their secular counterparts, their message is certainly worthwhile. Face it, styles of music change. Your daughter isn't likely to sit down and listen to the gospel groups you probably enjoyed years ago. If teenagers are going to respond at all to music with a Christian message, it will almost certainly come from a contemporary group.

When Lisa entered junior high school, the leaders of her church youth group introduced her to the music of Keith Green. I liked some of his songs; others I didn't. But she liked them all. I believe that Keith Green, with his emphasis on godly living, will have a great and positive influence on Lisa's music of choice for years to come.

The distinctive beat of rock music reaches many young people where they live. When its rhythm and sounds are coupled with the Christian message, rock can be a powerful form of communication. Moms, the beat does not make the music sinful, and it just might make something very worthwhile seem powerfully relevant to our teens.

• Daughter... •

Like most teenagers, music is very important to me. I fall asleep and wake up to my clock radio. I usually have the stereo playing in my room and car. I watch videos on TV and dance to the latest hits. If there isn't a radio around, I sing my favorite lyrics to myself.

It sometimes seems that my parents would like me to be content listening to their favorite "golden oldies." Can't they understand that times have changed? We teenagers have our own style of music, just like we have our own styles of clothes, cars, and dancing. And though they are right about some of the lyrics being pretty bad, they seem to ignore the fact that the words of many country-western and "easy listening" songs are not all that great either.

So how can we convince our parents that our style of music is okay? One thing that has worked with *my* mom has been to gently and gradually expose her to my favorite music. Parents seem surprised to find that not all modern music is screaming about sex, drugs, and destruction. There is some really good stuff out there.

If you decide to try my approach, be careful not to overexpose your parents. When I was in junior high school, I'd latch on to one favorite song every few weeks and that was *all* I'd listen to in the house and in the car. When there wasn't a tape player available, I'd sing that song—always at the top of my voice. Needless to say, my parents grew sick of my special songs very quickly.

Another mistake I made was to blast my music so loud at home that no one could hear anyone else talk. Sometimes my parents tried to be patient and at first put up with the noise. Other times they ordered me to turn the music off. But instead of trying to understand that their complaints were mainly about the volume, I told myself it was just that they hated my kind of music.

Like so many other areas of life that involve differences in taste, music is really a give-and-take situation.

If we want our parents to give us the right to listen to the music we like, we need to admit that they have the right to like something different. Don't constantly complain about your parents' choice of music. Even though country-western or the big-band sound may be far from your favorite, give it a chance if that's what they enjoy. Parents don't welcome complaints about their musical taste any more than we do.

Some of my favorite and most listened-to tapes are Christian rock. It has the same strong beat and style as pop rock, but with a Christian message. If your parents don't approve of popular music in general, this might be a good way to try to break them in. Even if they do okay other music, Christian rock is still great listening.

Whatever music you listen to, respect your parents' requests. If they ask you to turn it down—or off for a while—do it! They will appreciate your cooperation, and part of maturity is being considerate of the feelings of others.

• We Can Work It Out •

The key to living peacefully in the same house with someone whose taste in music is different from your own is showing respect for each other. Both parent and young person should have the chance to enjoy his or her own musical preference and should be able to do it without demeaning the other's preference. Respect also means using discretion in what you play, the volume level, how frequently you repeat the same tune

(and at what hour!). And it means sharing and listening
to legitimate concerns, such as the disturbing mood
certain music may produce and the importance of pro-
tecting one's mind from undesirable input.

The place to start negotiating in this area is by dis-
cussing and determining some house rules, based not
on prejudices but on general principles. Are there cer-
tain types of music—or specific groups—that will not
be allowed in the house? Are there certain times or
places that are off limits for loud music? Under what
circumstances can one of you ask for complete quiet
and expect to get it?

Musical preference calls for courteous give-and-take.
Compromise is not only appropriate, but absolutely
necessary in the interest of peace and quiet. And what a
wonderful opportunity it gives us to learn to appreciate
and even enjoy the uniqueness of another's tastes.

3

"Where Can I Go? What Can I Do?"

• **Mother...** •

I was fifteen when George asked me out. It was to be my first real date. "How about the school dance Friday night?" he suggested. I told him that I was not allowed to dance.

"Oh." He hesitated. "A movie, then?" I explained that I was not allowed to go to movies.

"Well, on Sunday some of us are going to the lake for a picnic...." I told him that on Sundays I never got home from church until one and later had to leave for evening service at five.

I'll never forget the look George gave me as he declared, "I sure am glad I'm not your religion. You can't do *anything!*"

The thing I remember most about the string of "don'ts" that governed the way I grew up is how much it made my friends and me want to go out and try each and every forbidden thing on the list. Some of us learned to be quite creative when it came to finding ways of sneaking around the prohibitions. Today's teenagers are no different than we were in respect to forbidden fruit. Pronouncing ultimatums is not the best way for us to relate to our kids, gain their cooperation, or teach them how to make mature decisions.

What should adolescents be doing during their free time? Probably the best answer is: a variety of things. When a teenager seems obsessed with only one activity, whether it's listening to rock music or working on the computer or watching television or jogging or studying, it is almost always a sign of trouble. Well-adjusted teens pursue a variety of interests. We parents must be careful not to push our teens so hard in any one direction that they have no time left for other activities.

Still, if you are like me, there will be some pastimes in which you don't want your daughter involved because you see inherent dangers she knows nothing about. Once, when I tried to explain to Lisa that I did not want her to attend an unchaperoned party at a classmate's home, she pleaded, "Come on, Mom, I can handle it. I'm not a child!"

I understand how Lisa feels. I've been there, myself. But I also know that teenagers cannot handle nearly as much as they think they can. And so I have to lay down some rules. Though I admit I'm often too quick to expect the worst, I try hard to keep the no's to a minimum, to save the negative approach for the things that

really matter. Hopefully, your daughter will choose to cooperate with the rules upon which you decide. If she doesn't, you may have a problem enforcing them, especially if you have been unsuccessful in explaining why you feel they are necessary at *this* stage in her life.

Carolyn's father was a youth minister in our town, her mother a Bible-study leader. The two never tired of commenting favorably about their "loving Christian daughter." Carolyn was the positive example in every illustration. "Our family rules are strict, but she never complains or argues," her parents boasted. "She never even questions us." The rest of us were not impressed. We had heard that behind their backs, Carolyn was sneaking around, breaking every one of their rules, a few of which seemed unusually strict to the rest of us parents.

Perhaps the key to enforcement is to avoid falling into the "me against you" trap. Mom, work toward enlisting your daughter's cooperation, not just resentful compliance. When she suggests an activity that makes you uncomfortable, don't pound the table and exclaim, "No daughter of mine will ever...!" Instead, listen to what she has to say about the activity; then ask her to listen to your concerns. In the end, you—the parent—will have to make the final decision, but make it as fair as you possibly can.

As Lisa matured, she was allowed to make more and more of her own decisions about where to go and what to do "for fun." Eventually her father and I told her that *if* she had evaluated the situation carefully and prayerfully—had listened to our concerns, could show us she had reasoned it out, and was prepared to take respon-

sibility for her actions—she could make her own decision about a specific activity. Only rarely have we been disappointed.

I cannot deny that relinquishing parental responsibility in this area was hard for me. And just because we "communicated" didn't necessarily mean I always approved of Lisa's decisions. But our challenge as parents is to sense when our daughters are mature enough to make their own decisions about how to spend free time and then to take responsibility for their actions.

• **Daughter...** •

Laura, a girl I know, has parents who are so protective of her that there's almost nothing she is allowed to do. She can see only G-rated movies of the Disney variety, and her TV watching is severely restricted. She can never listen to any popular music—and needn't even bother to ask about a dance! Laura knows the rules, but she does what she wants and dares her parents to do anything about it.

It seems that in many cases it is the kids who are faced with the most restrictions who are the most rebellious. When presented with a long list of don'ts, they want only to prove that they cannot be controlled by their parents' rules. Or maybe breaking the rules is a way of getting their parents' attention. I know kids like that, too.

A while back, when I wanted to go somewhere or do something I knew my parents didn't approve of, I used

to argue or sulk to get my own way. But very quickly I learned it did me no good. I got a lot further when I discussed the situation with them. Many times when they thought an activity was wrong for me, I disagreed—sometimes strongly. But unless a more or less mature discussion of the pros and cons followed my protest, no one paid much attention.

Several years ago, a dance place for teenagers opened up in town. Several of my friends wanted to go, and so did I. When I asked my parents, their first reaction was a definite "No!" They argued that it was in an area of town that wasn't safe at night. Furthermore, they weren't sure that the club itself was a good environment for me.

I was so upset with their decision that I called my friends and moaned that I "never got to do anything," that "no one trusted me," and so on. But after I thought about it I realized I would get a lot further if I quit complaining and thought of possible ways to convince my parents to change their minds. After several discussions, they agreed that I could probably go if I went with a large group of kids from church. They also asked that I wait a few weeks so they would have time to talk to other parents whose teens had gone to the club. I agreed to do it their way. It took a lot longer than I liked, but when I finally got to go, I had a great time.

Sometimes, of course, no discussion or alternative plan can work things out. It can be awfully disappointing and terribly frustrating not to be able to go somewhere or do something that is really important to you. But if your parents are like mine, they will be more lenient with their future decisions if you gracefully

accept as final a restriction they place on an activity to which they are strongly opposed.

• We Can Work It Out •

Together, take a look at your ground rules. Who made them—parent, teen, or both together? Has the daughter outgrown any of them? Are they realistic for both her and the entire household? Are rules enforced with vague threats and ultimatums, or with realistic and specific consequences? Is the list of "don'ts" long and inflexible? Does it contain things that, on closer look, are not really so important after all? Perhaps your list needs more work—some trimming or some additions, some defining, some flexibility.

In things that really matter, Mom, the final responsibility rests with you and your husband. Hopefully, decisions about the adolescent years can emerge from a two-way exchange. Remember, the time must come when your daughter will be expected to make multiple decisions and have the final say about her own welfare. Work together toward preparing her for that goal.

4

"I'll Get a Part-time Job!"

• Mother... •

The subject first came up when Lisa wanted to buy an outfit I thought was terribly overpriced and frivolous. "Eighty dollars for a pair of overalls?" I exclaimed. "Absolutely not! Do you think money grows on trees?" Lisa responded with pleas for a chance to earn some money of her own. At the tender age of fifteen, she wanted to get a job!

Lisa's dad quickly agreed that a job might be a good idea. Not only would it give her something profitable to do with her spare time, but it would also help ease our ongoing financial wars. It might even provide our daughter with sound money-management experience and help her learn to handle responsibility, he pointed out. He was ready to give Lisa his wholehearted consent.

As cautious Mom, I insisted my husband stop and consider the drawbacks of having a working teen.

"What about the rest of the family?" I asked. "It will interrupt our whole routine. How is she going to get to work, anyway? Am I going to have to be her chauffeur? And another thing—this could mean the end of our weekend trips and summer vacations!"

Every family can stand "a bit of change," I was told. And was I really going to complain about a little inconvenience when the list of pros seemed convincing? I stood my ground. I hated being the bad guy, but in a family the needs and wants of everyone must be taken into account. "What about school?" I asked Lisa. "With the extra pressures and responsibilities of a job, your grades might suffer. Most employers will want you to work more than just Saturdays. If you work after school, you won't have time for homework, much less anything else."

This objection didn't phase Lisa in the least. "No problem," she said. "I can do my homework fast when I have to, and I'll save the studying and hard stuff for the times I don't have to work." Evidently she had not yet learned that teachers have an uncanny tendency to join forces and pile on assignments for one night while also scheduling tests for the following day.

I asked Lisa to weigh realistically what she would have to give up in order to hold down a job. After-school clubs, sports, parties, church youth-group activities—these were all things she might have to curtail. "It isn't fair," I reminded her, "to expect a boss to give you time off just because there's a football game you don't want to miss. And he won't overlook your getting to work late on a Saturday morning because you had a date the night before and were too tired to get up on time."

I remember how it was when I was in school. When a teenager starts a new job, it's all fun and excitement and hard to understand that it won't always be that way. But making pizzas can quickly grow tiresome, and working a cash register can be boring. Even if Lisa liked the job, she might soon learn that not everyone is a pleasure to work with. Fellow employees can be lazy, rude, even dishonest. Bosses can be unfair, demanding, rigid. I didn't want her to learn those "facts of life" before she was ready. She might quit as soon as things got tough or keep changing positions in a quest for that "really fun job." Only by sticking out the rough times would she develop into the steady, consistent, dependable employee I wanted her to be, but for now it seemed better that she concentrate on school and being a teenager.

Together we all sat down and weighed the pros and cons of an outside job for Lisa. We agreed that if we decided it was not the way to go, we would help her think of other ways to earn money. Baby-sitting would not provide a steady income, for example, but it was flexible, would be good experience, and would allow Lisa to earn extra money. Or we could find other ways to employ her ourselves. For the two previous years, we had been paying her to clean our house once a week. Not only had this freed me from some work, it also gave her valuable experience in caring for a household. (For the last six months she had been cleaning for a neighbor as well.)

In the end, we were able to reach a compromise, one with which we were all happy. Lisa did go to work—in a nearby doughnut shop, an easy bus ride from home, and on Saturdays only.

Whatever her source of income, a teenaged daughter and her parents need to sit down together to discuss how she will use her earnings. Will it all be hers to do with as she chooses? Or will she have to accept responsibility for some of her own regular expenses? Will she be required to save a percentage? How about a regular donation to church? When you have different ideas of what constitutes "important" purchases, whose opinion will prevail?

When Lisa started working in the doughnut shop, we helped her plan and write out a budget. Though we all discussed and agreed on its guidelines, there was no insistence that she stick to it. The result was that soon after every payday her money was gone and she had little to show for it. Looking back, Lisa says I should have been more convincing about the necessity of sticking to her budget. She was the learner; I was the one who had once had the experience of managing the expenses of a young female adult!

That first job was good for Lisa. And because we had dealt ahead of time with many of the potential problem areas, most were eliminated, and Lisa was prepared for the rest.

● **Daughter...** ●

Clothes, Dutch-treat dates, movies, dances, vacations—these were only some of the things I had to spend money on. I didn't expect my parents to pay for all my "extras," but my weekly allowance didn't come

close to covering even my list of necessary expenses. I needed a real and dependable income.

A part-time job seemed the best way for me to earn extra money. Not only could I then pay for clothes, entertainment, and other regular expenses, but I finally had my *own* funds—money that I had worked for and earned. Having a personal income helped me feel grown up and independent.

I learned that part-time jobs have their drawbacks. Working took up a lot of the time I would otherwise have spent going out with my friends and doing other fun things. Fortunately, though it wasn't always convenient, I could usually reschedule time for my friends around my working hours. The really hard part was having to miss so many activities I liked. When I started working more than just Saturdays, I had little time left for things like cheerleading, sports, band, and choir.

When there wasn't much time, schoolwork was the easiest thing to push aside. It wasn't that my regular homework didn't get done; most teenagers, working or not, manage to find time for that. The problem was that there never seemed time for the special work, such as term papers, studying ahead for an especially hard test, or typing an essay instead of simply writing it out. I told myself those extras weren't really that important, but when my grades came out, I saw what a difference they made.

If you're like me, the most important thing to remember when considering a part-time job is time management. You'll probably have to drop some things from your busy schedule in order to find time to work, and you might not have as much free time as you would like. But it's important that you yourself make the

decision about what to cut out. Your parents can give input and they can say how they feel, but *you* must make the final decisions about your priorities. You're the only one who can really know what is important to you.

Through my part-time jobs, I've learned a lot about getting along with a variety of bosses and co-workers. Though I've made many budgeting mistakes, I've learned a good deal about handling money, too. My jobs have been my introduction to "making it on my own," and I've enjoyed a whole new kind of independence. Of course, working has also presented some problems and inconveniences, such as the activities I've had to miss out on.

If you are willing to plan ways to spend your time wisely, to work hard and make some sacrifices, I think you will get a lot of personal satisfaction out of a job. You'll also get a great deal of experience, some money of your own—and even some fun!

• We Can Work It Out •

A good place to begin your to-work-or-not-to-work negotiations is by considering the options. Are there other ways for your daughter— especially if she is in her early teens—to earn spending money and ease into the responsibilities of a regular job? Work at home? In a parent's office? In a friend's home or office? Baby-sitting or yardwork in the neighborhood?

Make a list of the potential shortcomings in holding a job, then consider them one by one. For instance, for

me, Lisa's homework was a big concern. It was thus important for us to decide together how much time she would set aside for studying. We agreed that if her grades suffered, the job would have to go. I also thought it important to look at the influences to which she would be exposed in a specific potential workplace.

Your family negotiations should also include working out the way your teen will use her earnings. Whereas Lisa thought in terms of extra spending money, I thought of her assuming more of her own expenses and/or saving something. Whether your daughter spends the entire amount on herself or puts it all in the bank is not nearly as important as that the two of you agree on the plan ahead of time. Don't wait until it becomes a problem. It's not fair, Mom, for you to constantly be on your daughter's case about her "wasteful spending"—or her "stinginess"—if you never agreed from the beginning on how her earnings should be used.

5

Now That She's Old Enough to Drive...

• Mother... •

From the time she was fourteen, Lisa knew exactly how long she would have to wait until she would be old enough to drive. When that magic birthday finally came, she thought she was all set to slide behind the wheel and drive off toward the good life of freedom and independence.

Not all parents agree that just because their teens are legally old enough, they are ready to take over behind the wheel. We didn't. Perhaps you don't either. And it just may be that we're right.

Actually, Lisa was much better prepared to face the responsibilities of driving than teens were in my day. Like most of her friends, she had taken driver education and behind-the-wheel training in school. Still, I shud-

dered about the grim statistics on teens and traffic accidents. We adults know that the nation's highways are terribly dangerous places to be, and new drivers lack our experience. Some also lack the maturity and sense of responsibility they need to be safe drivers.

We have probably all known moms and dads who won't let their teens do anything the parents feel puts their kids in danger—which ends up being almost everything. Throughout their growing-up years, these kids miss camp, pool and beach parties, school and church activities that have any remote element of risk. Kimberly's mother was like that. She wouldn't allow her daughter to participate in any activity that involved riding the church bus. Now, at sixteen, Kimberly is not allowed to ride in cars driven by other teenagers. Not only has she missed a great deal of fun, but the embarrassment her mother's attitude causes her has pretty much destroyed Kimberly's trust in her parents' values.

We parents cannot possibly protect our kids from everything that involves risk, so it's foolish to try. Rather than lock our children away from potential dangers, we need to train and prepare them. The following guidelines helped my husband and me move Lisa toward becoming the very best and safest driver she could be. Perhaps they will help you, too.

1. *Take your teen out in your car and let her practice, practice, and practice some more.* No matter how sincere, conscientious, and well trained she is, your daughter is still starting out as an inexperienced driver. The more practice she can get, the more skilled she will be in handling an automobile.

2. *From the beginning, set rules.* Where can she drive? How many kids is she allowed to have in the car at one time? Which car is she allowed to drive? Let her know that should she have an accident or near miss, or if for some other reason it seems appropriate, the rules are subject to change. And if the situation is severe enough, you have the right to restrict or remove her driving privileges.

3. *Be a good model of responsible driving.* As in everything, your daughter will learn far more from what you do than from what you say. It doesn't mean much to tell her, "Don't speed" if you usually do. Or to say, "Always come to a complete stop," if you consistently cruise right on through stop signs.

4. *Have your teen assume some of the responsibility for the family car.* She needs to understand the obligations that come with driving privileges: paying for gas, washing and maintaining the car, and helping to pay the insurance bill, for example.

Again and again, Lisa's dad and I reminded her that "driving is not a right but a privilege." I know she got tired of hearing that, but it's true. No one is automatically entitled to a driver's license merely upon reaching a certain age. Driving is a heavy responsibility, and any time a teenager (or anyone else, for that matter) fails to take it seriously, that person should lose the privilege to drive. In fact, irresponsibility in any area— schoolwork, behavior, obeying family rules—should cause parents to look closely at whether or not that teen should begin or continue to drive. This should be made clear to a teenager long before she reaches driving age.

• Daughter... •

In California, where I live, teens can get a driver's license at sixteen. When I was approaching my sixteenth birthday, I couldn't wait for the great day. All I could think about was the admiration and envy I'd receive when I showed up at school and church driving the yellow Volkswagen bug my dad had fixed up for me to use.

Was I in for a big surprise! My mom and dad decided that six hours of driver training did not make me road-safe. I thought I knew better, and I sulked and pouted, but I couldn't change their minds. They insisted that before I could take the test for my license, I had to log twenty consecutive hours of driving with no major mistakes. I kept a notebook in the glove compartment and recorded every fraction of a mile I drove. When I had accumulated over eight hours, I made a big mistake—I didn't see a stop sign until it was too late to stop, so I drove on through. I had to tear out my pages and start those twenty hours all over again. It wasn't until many miles, tears, and months later, that I was finally able to try for my license, a test I passed easily.

It's hard for most of us to realize that just because we've reached the age the law requires, we're not automatically ready to get our licenses and hit the road— even after taking the driver-education classes taught at many high schools. Maybe this is why so many new drivers get into accidents.

Even after I finally got my license, I still had many restrictions. I could have no more than two passengers

in my car at a time, and everyone in the car had to buckle the seat belts. My parents had to know where I was driving at all times, and I could not drive in downtown traffic until I had several months of driving experience. My dad insisted that I take financial responsibility for my car—pay for gas and minor repairs and my own insurance premiums.

I hated all those rules and regulations my parents put on my driving. They made me feel that they didn't think I was mature enough to take care of myself and my passengers. I couldn't understand why they were so worried. If I was a good enough driver to get a license, why couldn't I drive wherever and whenever I pleased, and with anyone I wanted? It was a long time before I was able to admit it, but those stipulations were good for me at that stage of my life.

• We Can Work It Out •

Responsibly careful driving can make the difference between life and death, not only for the drivers but also for their passengers and others on the road. It's unwise to negotiate when the stakes are so high. In a situation such as driving, parents have an obligation to set conditions and rules, even if their teenagers object. But be careful, Mom, how you present those rules. Be sure you have a reason for each one. If your daughter balks at accepting a certain condition, perhaps it's because you haven't taken the time to explain the reasoning behind it.

Daughter, try to understand your parents' concerns: your passengers' lives and your own are at stake. Even though it may be inconvenient and frustrating to have to live within the restrictions, you will be safer in the end by cooperating. The best thing you can do is patiently prove your maturity and responsibility and thus "earn" some relaxation of the rules in the future.

Good luck, happy driving—and be careful out there!

Peers vs. Parents

6

Those Crazy Fads

• Mother... •

The last time Lisa asked me to shop with her for a swimsuit, I groaned inwardly. We live in a beach community of skimpy bikinis, and choosing proper beachwear with Lisa had always meant trouble, at least ever since she entered the teen years. But, I breathed a sigh of relief when, on the way to the store, Lisa stated, "I want to get a one-piece suit this year, Mom."

My relief was short-lived. One-piece, yes. But what a *small* piece! Every bathing suit in the shop seemed identical: leg openings cut almost to the waist, front neckline slashed so it hardly covered the navel.

Lisa couldn't understand my dismay. "But, Mom, everyone else has one!" There was that phrase again: "Everyone else...."

Being accepted by peers is probably all teenagers' biggest concern. They need to fit in, to belong. And it's important that they do, for those who look or feel different can suffer terribly. We moms know this from our own experience as adolescents. Even so, it's hard for us to accept some of our daughters' styles, fads, and ideas about what is fashionable or "in."

In the past I have asked Lisa such things as: "Why are you making the legs of your jeans so tight? You won't be able to get your feet through!" or "Why in the world would you wear that faded old denim jacket with that nice dress?" or "Why did you have your hair cut two inches shorter on one side than the other?"

Lisa's answer to my confused "Why?" was always the same: "It's the style."

Thinking back, I'm sure she gave me the right answer, probably the only answer there was. And it probably was a complete explanation of her choices. Yet I must admit to a twinge of embarrassment when people looked questioningly at her hairstyle or outfit. (They probably had no teenagers of their own!)

Certainly a big part of this ongoing parent-teen controversy about fashions and grooming has to do with our conviction as parents that how *they* look reflects on us—on our taste and on our ability to influence and control our children. What do people think when they see our kids in what they consider to be weird hairstyles, sloppy clothes, or skimpy bathing suits? That we approve? Yet this is exactly what our kids are trying to avoid. They don't want to be extensions of us. They want to be people in their own right.

Actually, there are two parts to this concern. While a trendy hairstyle or "in" teen fashion may seem merely

unattractive or "odd" to a parent, other styles may be totally inappropriate, perhaps even bordering on indecent. Perhaps the best solution is to come up with standards of what is acceptable in your family and community—a "dress code" if you will. Mom, if you <u>allow your daughter a voice in determining the code</u>, she will be more likely to accept it with a minimum of grumbling. But do be flexible. Assure her that you are willing to revise it whenever she comes to you with a convincing reason to do so.

Let your daughter know she is free to choose her hairstyle and clothes as long as she accepts the guidelines of your family code. If she fails to stay within those limits, you have a right to step in.

Because our family code covers "decency" in swimwear, I immediately ruled out several of the suits Lisa and I saw that day we shopped together. Lisa ruled out some others when she tried them on, since how a suit looked on her was more important than what was "in." After those eliminations, the final choice was Lisa's. The new swimsuit was not one I would have chosen for her, but she loved it and I could live with it.

One last word of comfort: if you don't like the current fads, be patient. They will soon change. Some friends of ours have come up with a great idea. At each new fashion stage they take pictures of their kids wearing the latest styles and fads. "That way," the mother says, "we can look at the pictures later and all get a big laugh!" She's right. If you don't believe it, invite your daughter to spend some time with you looking through your old yearbooks!

• Daughter... •

When it comes to fashion, my mom and I have had some real battles. She often seems to think that just because *she* chooses not to wear a certain style, neither should I.

Sometimes at school or around town I'll see girls who look like their mothers shop for them in the women's department. They look as silly and out of place as middle-aged women who try to dress like teenagers. Sure, a mom should have some input into her daughter's wardrobe, but most of the choices should be left to the daughter. After all, she's the one who will be wearing the clothes.

Being a teenager is not as easy and carefree as adults seem to think. There is so much insecurity that kids who aren't in style really stick out. That's why most of us want to conform to our crowd's standards. This doesn't mean we want to look exactly like everyone else; we just need to fit in by not looking too different. If pegged pants are the fashion, no one wants to be seen in bell-bottoms. But we also want to be individuals and not look like clones of each other. So sometimes we'll add our own individual touch.

When I was a sophomore in high school, I looked very average. I dressed more or less like most other girls my age, and I had a "bob" haircut like everyone else. Then I decided that I wanted to be original, so I had my hair cut in a different style. It was angled off and about an inch and a half longer on one side than the other. Nothing really drastic. Lots of people didn't even notice.

My mom did notice, of course, and she let me know how she felt. She also let me know when any of her friends happened to say anything about it. It seemed that she was embarrassed by how my hair looked, and that made me feel bad. What I really resented was the pressure it put on me. But I was determined to stick with the hairstyle I wanted.

A simple haircut is not the kind of thing a mom should make into a problem—unless maybe a teenager comes home with a shaved head or a purple mohawk. I think parents should save the arguments for the big problems. I once heard someone say, "Don't sweat the small stuff." That really fits here. If a fad or style is not destructive or indecent, a mom should let it alone.

We teenagers can be pretty reasonable. We usually don't go beyond our parents' limits unless we feel there's good justification. Styles and fads change. <u>What we need are moms who trust our judgment and accept us as we are.</u>

• We Can Work It Out •

In our family, certain aspects of hairstyles, clothes, and fads are negotiable. Decency is not! I have finally pretty much reconciled my struggle between "What will my friends think if they see that outfit on her?" and "Since you're the one who will wear it, you choose." It is more important that Lisa knows I accept her as she is than that my friends admire her fashion sense. As for suitability, we often disagree. After many

arguments, I have had to admit that what is "appropriate" is largely a matter of personal opinion and changing cultural standards. I would never have thought of wearing jeans to church on a Sunday evening. Lisa has done it for years, and so do many other teenagers.

What are your family rules about grooming and dress? If you haven't any, it is important that you work together to set some. Hopefully, the list will be neither too long, too restrictive, nor too far removed from the reality of the teen world. But parents have the right to set some limits when propriety is involved. Stick to your rules on decency and make your reasoning very clear to your teen!

Mom, of course your daughter's manner of dress, hairstyle, and behavior reflect upon you. But it is terribly unfair to expect her to be your mirror image. (Did your own taste ever exactly reflect your mother's?) Nor is it fair to put upon your daughter the burden of making *you* look good. She is her own person and has the right to be respected as such.

And, parents, please understand how important peer acceptance is to your teen. The years when you were the most important people in her life are over. Now it is her peers whose approval she craves. That is a natural, normal developmental stage, so don't be surprised to find that fitting in with kids her own age is more important than pleasing you.

7

Drugs, Alcohol, and Smoking

• Mother... •

On a stifling hot afternoon in late September, I sat with about thirty other mothers at a PTA meeting in the junior high school cafeteria. The topic under discussion was alcohol and drug use among teenagers.

"My husband and I drink," said Sharon, a PTA officer. "It's a socially acceptable thing to do. Of course, I don't want my daughter using alcohol illegally, but there's no reason she shouldn't try it at home in moderation. It's the only way she'll learn to drink sensibly and not abuse alcohol later on. I know she's below the legal age for using alcohol, but we don't see a problem if she has a little under our supervision."

Evidently Sharon didn't realize that her eighth-grade

daughter was known around school as a wild and wel-
comed party-goer, one who always brought along a
thermos filled from her parents' liquor cabinet.

"My son doesn't drink, period," stated Cynthia. "No
questions, no comments. The matter isn't even open
for discussion in *our* house."

The reason this subject had come up in the first place
was that a week before, at a high school football game,
the heavy drinking of several seventh-and-eighth-grade
students had caused a serious problem. One child had
to be hospitalized. Although Cynthia's son was one of
those charged with drunkenness, she refused to believe
he bore any responsibility. "If my son was involved,"
she insisted, "he was pressured into it. He would *never*
drink willingly!"

Alcohol and drug use are rampant in our schools.
Many of the parents of kids who use these substances—
dangerously and illegally—have no idea what their
teens are doing. If you don't believe it, just take a
moment to think back to the things you or your friends
did in secret about which your parents knew nothing.
Like Cynthia, even when faced with clear evidence of
what is happening, some parents refuse to believe it.
Or, like Sharon, they minimize these situations as part
of "growing up" or even a learning experience.

Most teenagers are well aware of the link between
smoking and lung cancer and heart disease. They have
heard again and again the statistics relating drunk driv-
ing and teenage fatalities. They have also been pumped
full of information on the dangers of drug use. With all
the evidence and all their knowledge, why do kids still
drink, smoke, and use drugs?

Somehow, to many teens, no danger seems to register as real and personal. They believe themselves to be immortal, invincible, indestructible, and in "control." Perhaps part of the fault lies in parental hands-off attitudes, like Sharon's tacit approval of her daughter's drinking. But surely the strongest reason has to do with peer pressure to experiment. Neither a health warning in the media nor a parent's condemnation of an activity carries much weight when measured against the pressure and influence of other kids.

We warn our kids about what these substances do to their health and that alcohol for teens and drugs at any age are illegal. But their friends say, "Look at me. I use it and I'm fine. And I've never been caught. Your parents just want to scare you."

As Christian parents, we speak of "your body as the temple of God," and tell our kids of their responsibility to take care of it. Their friends say, "It's *your* body and *your* life. No one has the right to tell you what you can do with your body. Anyway, where in the Bible does it say you shouldn't drink or smoke or do drugs?"

We caution them that they don't understand what they're getting themselves into, that addiction is the outcome of even so-called casual use. Their friends say, "Everyone does it. Just be careful and you'll be able to stop whenever you want to."

Mom, if you or other family members use any of these substances, or if close friends do, you'll have an even harder time persuading your teenager to refrain. You will say, "Don't smoke [or drink]," and she will answer, "Why not? *You* do." You may reply "You

aren't old enough," but she will say, "Stop treating me like a child." If you say, "You'll be breaking the law," she might very well comment about the last time Dad used his radar detector to outwit the speed traps on the interstate.

Forbidding our teenagers to experiment with drugs, alcohol, and cigarettes is not likely to do much good. Fiery ultimatums seldom work. But we can help them reach their own decision to stay away from these harmful substances by:

1. Setting a good example by our behavior and choice of friends
2. Making our views—and our reasons for them—known to our kids in calm but certain terms
3. Being willing to talk openly and frankly about drinking, smoking, and drug use
4. Not allowing our young people to have large amounts of money for which they are not accountable
5. Making it plain by word and example that fun and social acceptance are possible without the help of alcohol, drugs, and cigarettes
6. Not allowing teens to go to parties or other places where alcohol or drugs are used
7. Not allowing teens to have unsupervised parties or to attend them, even when it means giving up our own free time to do the supervising
8. Making sure teens understand that drinking for a minor and drug use at any age are against the law
9. Working with school personnel to establish policies concerning teen drinking, smoking, and drug use

• Daughter... •

Several years ago, one of my friends and I were invited to a party at a local beach. It was going to be a great party, we heard. Lots of kids from our school were going, as were many from other schools in the area. Since neither my friend nor I had a driver's license, we planned to have our parents drop us off and later ask some of the older kids at the party to drive us home. It was a perfect plan for a great evening.

But things didn't go as I planned. When I asked my parents if I could go, they asked if there would be any alcohol at the party. I told them it was possible, but that neither my friend nor I would be drinking. So I stayed home—and *not* by choice! Though I can understand my parents' concern for me, I would have appreciated more trust from them.

To me, staying away from a party just because alcohol will be served is not the answer. I figure that by not drinking myself, I will be a strong, positive influence at a party. When I go with like-minded friends to a party where others are drinking, we carry around colas as evidence that you don't have to use alcohol to have a good time. Some adults may find it hard to believe, but many teens do respect this viewpoint.

Alcohol is the most prevalent drug among high-schoolers, but smoking and using hard drugs are other dangerous practices found among teens. While I don't always choose to avoid situations where there is alcohol, I stay away from places where there is smoking of any kind. Not only is smoking (whether of tobacco or

marijuana) harmful for the users, but non-smokers who have to breathe in their smoke and fumes are also hurt. And, needless to say, I *never* knowingly stick around a gathering where hard drugs are being used or peddled.

• We Can Work It Out •

How times change! When I was a teenager, cigarettes were an issue only among Christians. Smoking was generally accepted socially, at least for adults. Scarcely anyone talked about health hazards. And hard drugs were pretty much unknown, so were not yet much of an issue. Alcohol was the big scandal on campus: "bad" kids used it, "good" kids didn't. In fact, many were drawn to it just as a means of breaking out of the "good kid" mold.

Now hard drugs and smoking are frighteningly wide-spread issues. We are constantly presented with terrifying studies, statistics, and examples of their destructive results. And we all have to worry about being indirectly affected by the drug and tobacco use of others. Sometimes it seems that alcohol, the most used and abused of the three harmful items, seems to cause the least concern in the general public, except when connected to driving.

I agree with Lisa's stand against attending activities where she might be subjected to "secondhand" smoke. With all we know about the dangers of smoking, staying away is a wise decision. But while I appreciate her

desire to be a "positive influence" at parties where there is drinking, I cannot approve of her attending teenage social functions that involve alcohol. Inexperienced drinkers, especially, tend to think they can handle more than they actually can. And even those who can control their own behavior cannot control the actions of others. There is no more bitter evidence than the horrors of the highway slaughter caused by drinking drivers who were certain they could drink and drive. And one matter Lisa neglected to mention— underage drinking is illegal!

The key here is not just the young person's age and performance record. A high-schooler has no business even attending a party of peers where there is alcohol use. Nondrinking older teenagers who have proven their responsibility might be a somewhat positive influence on the other partygoers, although I'm not convinced that this either works or is a role teenagers should play. Certainly an occasion that includes illegal behavior of any kind is inappropriate for them, regardless of their good intentions.

Warning Signs

If you suspect that your child is using drugs or alcohol, these clues may help you to confirm your suspicions.

1. *Signs of drugs, drug paraphernalia or alcohol*

 Drugs, unexplained pills or their containers, cough-medicine bottles, or alcohol containers "mysteriously" appear in your teen's bedroom or bathroom. Also, the odor of drugs or alcohol, or the smell of "cover-up" scents such as incense or mouthwash is apparent.

2. *Identification with the drug culture*

Teen is reading drug-related magazines or displaying drug-culture slogans on clothes. Conversation is preoccupied with drugs and teen associates with people known to be drug-users.

3. *Physical signs*

Teen has difficulty in concentrating, poor physical coordination, slurred speech, unhealthy appearance, indifference to hygiene and grooming, bloodshot eyes or dilated pupils, drowsiness, and frequently wears sunglasses.

4. *Dramatic changes in school performance*

There is a distinct downward turn in teen's grades (not just C's to F's, but A's to B's and C's). Assignments are not completed. Increased absenteeism or tardiness, or discipline problems surface.

5. *Changes in behavior*

There may be trouble with the law, and a defiant breaking of reasonable rules. Abrupt changes in friends are made. Parents are given little information about friends or activities. There is increasing and inappropriate anger, hostility, irritability, secretiveness, and little motivation, energy, self-discipline, and self-esteem. Interest in activities such as sports, social events, and hobbies is diminished.

Remember, symptoms are not proof! But certainly a teen who exhibits several of these physical or emotional signs needs some kind of help with her (or his) life.

Where to go for help

National drug and alcohol abuse hotline can be reached by calling this toll-free number: 1-800-BE-SOBER.

Alcoholics Victorious is an international fellowship of Christian recovering alcoholics. It has more than a hundred chapters throughout the world. Founded on Christian principles, this group is committed to help alcoholics overcome their problems by using God's strength. For more information contact: Alcoholics Victorious, 123 S. Green Street, Chicago, Illinois 60607.

Al-Anon is a support group for families who have to cope with an alcoholic relative. Associated with Alcoholics Anonymous, it has chapters throughout the country. For more information contact: Al-Anon Family Group Headquarters, P.O. Box 183, Madison Square Gardens, New York 10017.

Alateen is the division of Al-Anon for teenagers. Contact them at address listed above.

Your minister or your teen's school counselor may have other suggestions. In many communities help is available through agencies such as the Jewish Board of Family and Children's Services, Catholic Charities, or the Salvation Army. Check your telephone directory for local numbers.

8

"You Never Like My Friends!"

• Mother... •

Ever wonder why your daughter's selection of friends is so unusual (to say the least)—or realize that her lament that you *never* like them is not much of an exaggeration? What's a mother to do to help a daughter make healthy choices in friends?

Once we parents understand the tremendous power of peer pressure, we can't help but be concerned about the friends with whom our teenagers choose to surround themselves. My tendency, especially when Lisa was younger, was to attempt to pick her friends for her by steering her in the direction I thought right. I tried to do it gently, unobtrusively, casually. I thought if I just

dropped a hint here, a comment there, that I would be able to influence her friendships without her knowing it. It didn't work. Evidently my hints and comments were not as subtle as I had supposed. And I probably didn't really understand much about adolescent friendships and what qualities a teenager looks for in a friend.

Lisa resented my interference, and with good reason. It was important that she be able to choose her own friends. When I finally pulled back and let her do it, I had to admit she generally chose wisely.

Darlene, the mother of one of Lisa's friends from church explained her determination that her daughter associate only with other Christians: "I don't want Lori to be faced with worldly influences she can't handle. Not yet, anyway. She goes to a Christian school and to church. There are plenty of nice kids there. She doesn't need to look elsewhere for a social life. And that way she'll never get in a situation I wouldn't approve of."

I can understand Darlene's point. It is comforting to have our daughters surrounded by other Christian kids, isn't it? But it isn't scriptural. Christians are to be "the salt of the earth." That means it is up to us to exhibit Christ to those around us. How can our daughters do this if they never associate with anyone but other Christians?

Nor are Christian friends always the totally positive influence we expect them to be. In fact, lulled into a false sense of security, we sometimes fail to see the negative pull some nominal Christians can exert. So do our daughters. "What can happen?" they'll ask with a shrug. "I'm going to be out with a group of kids from the church."

This is not to say that Christian friendships are not important. They are. If a teenager stands alone among a group of young people who have neither moral convictions nor any restraints on their behavior, she will find it difficult indeed to resist temptation and the pressures of the group. Any of us would. Our young people need Christian friends to give support and stand with them.

So what are parents to do? Well, we can watch, we can listen, we can show our interest. We can be a friend to our daughter, which includes awareness of her needs and contributing as much input as is welcome. We can also make sure our teenagers have the opportunity to meet kids with similar beliefs and values. Of course, the time may come, Mom, when you will have to flatly refuse to allow your teen to associate with a certain person. But do save this type of restriction for truly extreme circumstances.

Perhaps the charge of "You never like my friends. All you do is criticize them" comes from the fact that we moms have a tendency to dwell on the negative. Let's not forget the positive. Encourage your daughter. Help her work through the heartaches and questions and problems she encounters as she forms relationships, changes them, and establishes new ones.

Most of all, support her with your prayers. In John 17, the Lord prayed for his disciples: "I'm not asking you to take them out of the world but to keep them safe from Satan's power.... Make them pure and holy..." (vv. 15, 17, TEV). Should we not pray the same for our daughters?

• Daughter... •

The subject of friends is usually a touchy one between us teenagers and our parents. It seems that our moms and dads rarely approve of our friends. They nag and they criticize; then they wonder why we don't want to listen more closely to what they have to say.

I can remember one friend I had in junior high whom my parents really didn't like. I had just broken away from an overly reserved and serious-minded group of friends and was trying to get out and meet new people when I got to know Amanda. She was on the drill team with me, and she was pretty wild. One weekend Amanda and I—both thirteen-year-olds—sprayed our hair pink, painted our toenails black and glued on two-inch long red fake fingernails.

Needless to say, my mom was not happy about my friendship with Amanda. But she did the right thing. She let me find out for myself that Amanda was not the kind of friend I wanted, and that only took a couple of weeks. (It's a good thing that Amanda and I didn't stay friends. Today, at seventeen, she takes drugs, has a short spike haircut, and is failing high school.)

Usually my mom is right about the kids I should avoid. But she is not always right about the friendships I should have. Sometimes she is too quick to judge without knowing enough about a particular girl. For example, soon after Amanda and I broke off our short-lived friendship, my mom decided she would like me to be friends with a "nice, new girl at church" whose mother she knew casually. As soon as I met Danielle, I

knew she was definitely not my type. She was pushy, very loud, and talked constantly at the top of her squeaky, high-pitched voice. But my mother, who hadn't even met Danielle, insisted that I get to know her, so I finally did.

It was arranged that Danielle and I would go together to a Wednesday-night youth group at church. My other church friends also tried to be nice to Danielle, but we all ended up incredibly embarrassed. About halfway through the Bible study, Danielle said something she thought was funny. Immediately she started squeaking and giggling and rolling around on the floor. Everyone stared. Oblivious to the looks she was getting, she kept it up until the leader asked her to leave the room. Needless to say, my friendship with Danielle broke off almost before it began.

My point is that parents should try to keep out of their daughters' friendships. If a girl is in a bad situation, she will usually get out on her own. Only if she doesn't get out—just as if I had stayed with Amanda much longer—should parents intervene.

Moms, when you meet a woman at church or anywhere else who has a daughter who just happens to be the same age as yours, don't expect them to become instant friends. Simply because you and the other mother hit it off doesn't mean your daughters will. There are few things more awkward than a "blind friendship."

Daughters, keep your eyes open. If you find you are doing or saying things around certain friends that you normally wouldn't, evaluate that friendship. If a friend makes you feel uncomfortable, you can probably do better.

• We Can Work It Out •

When it comes to friends, teens resent just about any interference from their parents. Yet, because parents know how dangerous peer pressure can be, they worry about friendships they consider questionable. What makes this problem so difficult to resolve is that both sides have validity. In working toward a solution, there needs to be found a balance between a daughter's feelings and rights and her mother's responsibility for guiding and protecting her.

Mom, I agree that you need to step in and call an end to any relationship that is definitely harming your daughter or putting her in potential danger. The question is: How? Nagging or criticizing the friend by pointing out her weaknesses will probably just cause your teen to hang on more tightly than ever. Forbidding her to see the friend can make your daughter resent you and rebel. Besides, it's hard to enforce. How can you be sure she isn't continuing the association at school?

There is another option: get to know the friend by opening your home to her. Once you know her, you may or may not change your opinion of her. Either way, you will be in a much better position to discuss with your daughter the specific concerns you do have.

If your daughter consistently chooses to associate with an undesirable person or group, you are probably facing an entirely different and more deep-seated problem. Does she have difficulties with her own sense of self-worth? Could this be her way of rebelling? Is she trying to make a statement? It might be helpful to get

some advice from your pastor, a family counselor, and/ or your daughter's advisor at school.

But—unless it is a really big problem—I think Lisa's advice is probably best: Mom, back off from your teen's friendships.

P·A·R·T
THREE

The Dating Game

9

Old Enough to Date?

• **Mother...** •

"Not yet twelve, and already she's had her first date," Anita's mother bragged to her garden club. "The two of them were so cute going off to the movies together."

"There's no reason for a girl to go out with a boy before she's at least sixteen. Eighteen is even better," Dianne insisted. "Our Amy knows that's our rule and she respects us for it."

"I wish my daughter would date," said Louise, "but she doesn't seem interested. I mean, she's fifteen years old. Is something wrong with her?"

When should a girl start to date? Probably every one of us moms has wrestled with this question. Like many other questions involving teenagers, it's a particularly tough one because it has no one right answer. In a

survey conducted in 1984, *Seventeen* magazine asked its readers how old they were when they started dating. Here's a summary of the responses:

12 years old or less .5.3%
13. .11.7%
14 .21.2%
15 .26.2%
16 .18.6%
17 .3.0%
18 or older. .0.7%
Don't know .13.3%

If your thirteen-year-old tells you that some classmates can already date, she *may* be telling you the truth. But that doesn't mean you have to allow her to do the same. And, though (according to *Seventeen's* survey) about 60 percent of its readers began dating before sixteen, not all girls are ready to date by that age.

When Lisa was in sixth grade, a neighbor boy asked her repeatedly to "go out" with him to the movies, the roller-skating rink, the beach, and several other places. At first she wasn't interested, but by the next school grade his ideas began to sound more appealing to her. Her father and I felt she was too young to participate in any one-girl/one-boy situation, but it was obviously time for us to set down some dating guidelines for Lisa.

We decided then that Lisa was not to date until she started high school. For the first year her dates were to be with boys we knew, and—with very few exceptions— they had to be with a group or at least another couple.

Lisa was not always happy with our rules. First off, she didn't want to wait that long for her first date ("My friends' parents don't make them wait till high school"). Later, she wanted to date boys from school we didn't know ("So what? *I* know him!"). Also in that first year, she often was invited to go where there would be no other couples included ("Come on! It's only to a movie!"). But she knew our rules because we had discussed them carefully with her. Like it or not, she had to abide by them.

It may be that our rules seem too strict for your situation. Or maybe they are too lenient. That's all right because you should make up your own list. Some aspects you might want to consider are your daughter's maturity, the responsibility she has shown in other areas of her life, the maturity and dependability level of her friends and potential dates, appropriate dating destinations, acceptable dating circumstances (group dates, car dates), reappraisal of curfew hours.

Once your rules are set, be sure your daughter understands and agrees to abide by them. Be willing to adjust the guidelines as she grows in chronological age and general maturity level.

• Daughter... •

When I was in junior high, many of my friends had already started dating, some in groups but others as couples. A few were even going steady. I wanted to date, too, but my parents had decided I had to wait until I started high school. Some of my other friends couldn't (or didn't want to) start dating until they were sixteen.

We all did a lot of talking about what was a good age to start dating.

We agreed that it was important for both our dates and ourselves to be "responsible." Of course we all thought *we* were, though we had doubts about some of the kids we knew. Deanna, for instance, bragged that she was always telling her parents she was going one place when she was actually going somewhere else. And she was never in "on time," she said. After a while her parents made her stop dating until she could show them she was responsible.

Susan's parents allowed her to start dating early, but at first they wouldn't let her go on "car dates" (in which the boy drives the girl in his or his family's car). Ashley's parents allowed her to go on car dates as long as there was another couple along.

I guess the thing our parents tried to get across to my friends and myself is that where dating is concerned, a lot needs to be taken into consideration. The exact age is not as important as a girl's maturity and willingness to accept responsibility and follow her parents' guidelines. Most of us had to prove those qualities before we were allowed to date.

• We Can Work It Out •

Perhaps instead of beginning this discussion by asking, "How old is old enough to date?"—a question that is sure to start mother and teen out arguing—we should really consider under what *conditions* dating

should be allowed. This way, a parent can lay out some absolutes, and a daughter can know what to expect and at what age.

A good way for young teenagers to start dating is for them to go out in boy-girl groups to movies, church and school activities, or other community attractions and recreation spots. At first this "dating" should probably be limited to daytime and early-evening hours.

As a girl proves she can handle these first dating experiences in a responsible manner, she can begin to be allowed single dates. Mom, you might want to consider several questions: How mature is your daughter emotionally? How does she handle herself in judgment situations, especially where there is a lot of peer pressure? How mature is the boy she wants to date? Where do they intend to go? Are they going alone or with another couple? Will they be going in a car? If so, who will be driving?

It's true that in dating, just as in so many other situations involving parent-child decisions, "Tomorrow's privileges are based on the way you handle today's responsibilities."

10

Setting Conditions for Dating

• Mother... •

It was the August between Lisa's freshman and sophomore years in high school, and Amy Grant was in concert at the county fair almost a hundred miles up the coast. "Some kids from church invited me to go," my daughter announced excitedly.

Already I didn't like it, even though I did approve of Miss Grant's style of gospel singing. "It's an awfully long way," I said. "Who's going to drive?"

"Paul Stevenson. Mike and Sandy are going, too."

"Doesn't the concert start in the evening?" I pressed. "What time would you get home?"

Lisa explained that the plan was for the four of them to drive up early in the afternoon. The concert was to

start at 8:00 P.M. By the time it was over, allowing for
the crowd and the long drive, they figured they would
be back in town sometime between 1:30 and 2:30 A.M.

Lisa couldn't understand my objections, which I
stated pretty clearly! "I don't know any of those kids
very well, but I've heard a lot about Paul," I told her.
"He's done a lot of irresponsible things, like the time he
and his friends had that wild party when his parents
were out of town."

"Oh, Mom, that was when he was younger. He's a
senior now," she explained, though that didn't make
me feel any less uneasy.

I knew how much Lisa wanted to go. And it was a
Christian event with kids from church. Still, neither
her father nor I felt comfortable about her going. We
tried to explain our concerns, but Lisa just couldn't
understand why we were being so "unreasonable."

In the end we told Lisa that because her safety and
well-being were our responsibility, the final decision
and its consequences must also be ours. Lisa stayed
home. Paul, Mike, and Sandy went without her. The
three apparently had a wonderful time and arrived
home safely with glowing reports of the great concert.
Lisa was so angry, she would hardly speak to me for
days.

The dating years are sure to provide us parents
with plenty of conflict. Though we don't enjoy saying
no, and our daughters can't understand many of our
concerns, we sometimes have to be willing to be
"the heavy" and impose the restrictions we think are
necessary.

Yet it's important that we be sensitive in our rule
setting and in our giving of advice, no matter how

well-intentioned it is. We need to demonstrate to our daughters that we have their best interests in mind when we set limits. It's so easy for them to feel trapped between pressure from us and pressure from their friends. (That's why it will be much easier for your daughter to accept your decisions and stand up for her convictions if she has at least one friend who shares her moral values.)

Again, Mom, the conflicts can be greatly reduced if you set up boundaries ahead of time and make sure your daughter understands them. Most dating problems center on where she can go, how she is getting there, and when she has to be home—all legitimate concerns for parents. Usually it is when these matters aren't clarified until the last minute, after a girl's plans have already been made, that arguments arise.* She has a right to know ahead of time what will be expected of her.

Remember when you were a teenager, Mom, how much fun it was to be spontaneous? Pizza at the beach at midnight, swinging in the playground while eating ice cream cones, putting pennies on the tracks for the train to run over—those impulsive things were often the most fun of all. Yet our teenagers need some clearly stated guidelines from us to help them decide whether or not a particular activity is appropriate.* When she comes in, breathless with excitement, to tell of her fun

* Single moms: You may find this is a difficult area for you and your daughter. A teenager's concept of herself and her role in life comes from how she is treated by others. You can help compensate for her missing father by being sure she has positive, caring male role models in her life.

evening, and you respond with, "You did *what?*" she has little choice but to be defensive. And her easiest defense is, "You never want me to have any fun!"

The worst thing we parents can do is provoke our daughters into taking desperate and rebellious action. When we give ultimatums and pronounce unbending statements, that is just what we are in danger of doing. Certainly there are absolutes that don't change— biblical admonitions and guidelines, the basics of human nature. But many things are relative. Times change, situations change, our daughters change. And *we* sometimes need to change, too. Leave room for a possible reconsideration. Your willingness to examine her point of view will let your daughter know you care.

• Daughter... •

When I started dating, my parents didn't seem to mind my going on car dates, but they did have other specifications. They liked it if I dated guys from church, though that was not a requirement. It was a rule, though, that my parents had to know the guy before we went out.

I can remember one time when I was a freshman, there was a junior guy that I was very interested in. We had met at a football game, and he asked me to go to a movie. But before we could go out, my parents told me, he had to come over to our house so they could at least meet him. Though I was very nervous and uncomfortable about asking him over to talk to them, as it turned out he was happy to do it. He came over and everyone

visited and talked for almost an hour. It all went very well. The point is, sometimes the rules parents set up can seem silly or embarrassing but work out much better than we expect.

As I grew older, the rules for dating were fewer and more flexible. That's how it should be. There is a big difference in maturity between a thirteen-year-old and an eighteen-year-old. Many of us will be away at college or out on our own after we graduate from high school— and then we won't have anyone to make our decisions for us. So, by the time we are seniors, we should be able to pretty much make our own dating choices.

One important condition to consider is that although most teenage dating doesn't lead to marriage, some does. And every girl and guy who get married had a first date with each other at some time. So things are less complicated if you date other Christians. This isn't always an easy thing to do, and I haven't always done it myself. For one thing, there isn't always a selection of available Christian guys around. And even if there are, some non-Christian guys are actually more moral than a few Christians I've met. This probably doesn't seem like much of a big deal now, but there are usually quite serious problems when a Christian marries a non-believer.

Moms, be careful when you set conditions for our dating. Be fair, and be willing to make exceptions to the rules every now and then. Your being flexible shows us you understand that there are different dating situations and that you respect our individuality and our judgment.

As for us, we know you moms are wiser and more experienced than we are, even though we don't always

like to admit it. And we know you're only trying to look out for us with all your rules and conditions. But don't try so hard to protect us that we can't breathe. Then we won't be able to get along with you.

• We Can Work It Out •

As previously mentioned, because arguments tend to arise or be magnified by time pressure, it is important that both mother and daughter understand ahead of time what dating practices are acceptable and what are not. Why not sit down together and write up a brief list that clearly states a policy on the most important dating conditions? You could include such subjects as curfew, under what circumstances Daughter is to notify Mom about changes in plans, what activities are acceptable and which forbidden.

As you work out this list, allow enough time to listen to each other. Mom, because you are a parent you have a right and a responsibility to express your concerns, raise questions and issues that are important to you and set some rules. Daughter, you have a right to have matters discussed with you in an adult manner and to be allowed to present your point of view.

In 2 Corinthians 3:6 we read that "the letter [of the law] kills, but the Spirit [of the law] gives life." When you are working out your policy, begin with basic principles and emphasize these over specific rules and regulations. Stressing the regulations and ignoring why they were laid down will encourage rebellion and

legalism. Raising a daughter on sound principles that she can understand will enable her to cope with all your rules.

Writing out your policy is only the beginning. Take it a step further by agreeing that any departure from the guidelines must be discussed *before* plans are made. Also, schedule a review of the agreement periodically.

11

Who Qualifies as
a Suitable Date?

• **Mother...** •

For weeks we had heard fourteen-year-old Lisa and her friend Susan talk about Dirk. He sounded like a real nice guy. He apparently hung around with some of the kids from church, his older brother taught a Sunday-school class, and his parents knew friends of ours.

One day when I drove Lisa and Susan to the beach, I finally saw the boy. It was enough to send me into shock. His bleached-blond hair was long, but not long enough to hide the huge homemade earring dangling from one ear. His appearance, his stance, his whole demeanor spelled "rebel" to me.

When she got home, I asked Lisa where she had met Dirk.

"He's a friend of Susan's," she answered brightly.

As casually as possible, I asked if he always wore an earring in his ear.

"No," she said. "Sometimes just a safety pin."

I was not comforted. Evidently Lisa noticed my disapproval, because she quickly added, "He's real nice, Mom. You just have to get to know him."

Off and on during the rest of the school year, Lisa talked about Dirk. The more I heard about him, the more unhappy I became. Dirk's life was pretty much unsupervised, unhampered by rules. Apparently, school was low on his list of priorities, and he seemed unconcerned about what others thought of him. But whenever I made any comment about Dirk, especially his appearance or unorthodox behavior, Lisa jumped to his defense. "You just don't like him because he's different," she accused.

To some extent she was probably right. I do feel more comfortable when Lisa associates with boys who are more mainstream. Those whose appearance is unusual alarm me. I admit it: I tend to fear the unknown. (But don't most people?)

Teenage girls have a whole array of complaints about their parents' opinions of the boys they choose as friends, but a major concern is age. "They say he's too old," Debra complained. "They just can't accept the fact that I'm not a baby anymore. Besides, I've heard that girls mature at an earlier age than guys."

Several years of age difference doesn't much matter between adults, but it *does* in younger people. Debra was a fifteen-year-old high-school sophomore; her boyfriend a nineteen-year-old-sailor. Those four years put

them in different worlds—even if girls *do* mature faster. "Debra thinks she is so mature that the age difference isn't important," her mother explained. "Yet she can't even discuss her point of view without getting angry and defensive. How mature is that?"

Debra and her mother were finally able to reach a compromise: She could go out with her boyfriend as long as it was with another couple or in a group situation. Or she could have him visit her at home. This last idea seems to have worked out well. "The more I get to know the boy," Debra's mother concedes, "the more I like him."

Joy had a different complaint. "My parents like Dave, but they want us to break up because they think we're too serious." In this case, it was Joy's mother who suggested a workable compromise. "If you would just lighten up and slow down," she said, "I wouldn't worry so much."

Not only did Joy follow what her mother suggested, she went one step further. She told her mother that she and Dave had already discussed their relationship and decided not to make any plans until they were older. "It made me feel a lot better just to hear her say that she and Dave had talked it over, and that they are not about to do anything rash," said Joy's mom.

Is it all right for a teen's date to be of a different race or religion? What if he has a totally different lifestyle? How much older can he be? These are questions the two of you should discuss. You may find that you are not as far apart in your ideas as you think.

• Daughter... •

"Mom, would you be upset if I dated a guy of a different race?" I asked one day.

"Well," my mother replied, "I'd like to say it really wouldn't matter, but honestly, I think it would bother me. I mean, just think of all the prejudice you'd face."

"People really don't care about that like they used to," I told Mom. "Don't you think that if you really love someone, race shouldn't matter? That's what *I* believe!"

"It's true that people are more accepting now of interracial relationships," she said, "but when I grew up, anyone who got involved in one was given a very hard time. I guess I'm still a little old-fashioned."

I was really shocked. I had always felt that my family was very socially aware, totally unbiased and open-minded. I didn't think they would react much to my dating guys who were ethnically different.

Although it is great when our parents like our dates, they don't always approve. Dates of different races, religions, and appearances can really worry them, though some families are more strict about those things than others are. If your parents disapprove of your dating someone who is really "different," check your reasons for wanting to date that person. Do you really like him, or are you just drawn to what has been forbidden by your parents? If you truly like him, give him the chance to show your parents that he's a nice guy with good intentions, and they might accept him.

I had a friend who started dating a guy that her parents flatly disapproved of. They didn't like his un-

usual haircut or the earring in his ear. Also, her parents had heard that the boy's father didn't have a job and gambled away any money he got his hands on. My friend and this guy really liked each other, but when her parents found out about the relationship, they were furious. Because of his offbeat appearance and his dad's reputation, they didn't even give him a chance.

As long as we live with them, our parents are responsible for us and should have the last word about our dates, tough as that seems. If your parents are objecting to your boyfriend, fellow teen, don't try to sneak around behind their backs. If you are honest with them, they will trust your decisions a lot more. So speak up. If you think they've dismissed a really great guy before they even got to know him, why not ask them to meet him and give him another chance? If they agree, you might all be pleasantly surprised at how well the meeting went. Then again, after seeing how the boy acts around your parents, you might decide he's not so great after all.

• We Can Work It Out •

Sometimes it's easier to work things out if you zero in on the specifics. Why, Mom, do you object to a certain boy? Does he have particular behaviors or characteristics that you always find offensive? What are they and why do they bother you? Are they really all that important? (They may very well be, of course.)

Some teenagers complain to their parents, "You don't like *any* guy I like." Sometimes that's true. If this

is a problem between the two generations in your family, see if you can figure out the reason. Do the boys share any similar characteristics? It may be that you will be able to spot a pattern. Then, Mom, you can begin to work on the specifics of why this type of boy seems so attractive to your daughter. Or is it possible that you just don't want her to grow up?

Mom, when you want to criticize the externals, such as a boy's manner of dress, try discussing instead such things as his character, values, and maturity. Many problems will then be easier to resolve with your daughter, and the resolutions will mean much more if she can see some of the flaws in her current interest that you do.

Daughter, how do you react when you mother offers her objections? Yelling, pouting, or generalizing ("You *always*...") is only going to reinforce her feeling that you are not mature enough to handle the situation. Try a different approach. And try also to see the boy through your parents' eyes.

No matter how you work together, there may still be some real differences of opinion between you concerning who is and who is not a suitable date. In the end, as long as you are living at home under their protection, your parents should be the ones to have the last word as to who is a suitable date for you.

12

Talking About Sex

• Mother... •

Six of us, all mothers of teenage daughters, were sitting around the table drinking coffee and talking. "Mindy is going out on her first date Friday night," Carla told us. "Guess I'd better take her aside and talk to her about...you know, not getting into trouble."

"I've got news for you," Nancy said with a laugh. "She already knows."

Nancy was certainly right. Most kids today are well informed about sexuality by the time they start junior high. But we cannot afford to leave it to movies, television, and other kids to provide our young people with what passes for "sex education." We can't even depend upon the programs at school that present only the

unadorned facts. Unless *we* teach our children, we are not in control of what is being taught, including the moral issues involved in making sex-related decisions.

"I don't want to talk to my daughter about sex," Kathleen admitted. "She's only thirteen and does know about menstruation. I don't want to give her ideas."

Mom, don't be afraid that discussing sex with your daughter will spark her curiosity or give the impression that you expect her to be sexually active sometime soon. It won't. In fact, just the opposite may be true. There is evidence to suggest that knowing all the facts and issues makes it less likely that a young person will experiment. Nor should such a discussion be limited to the physical aspects of sex and its potential medical dangers. It should also include topics such as values and morality.

"How in the world would you ever bring the subject up?" Ann asked.

"Don't make a big deal about it," Nancy said. "It's so much more comfortable when it comes up naturally. Like the other afternoon there was a program on television about teenage pregnancy that we happened to watch together. We picked up on that. At dinner I asked my daughter, 'What's the situation in your school?' She told us about a pregnant girl in her history class. Later, while we were doing the dishes, she went on to discuss her friends' concern about the pregnancy. That led to some talk about attitudes toward virginity and lovemaking."

Probably one reason Nancy's daughter was willing to talk so openly was that her mom didn't put her on the spot by asking directly what she thought or did. Instead Nancy showed openness, interest, and willingness to

listen. In exchange, she learned a lot about her daughter's world and was also able to get in some low-key advice without lecturing.

"That's fine for you," Gail told Nancy, "but I couldn't talk to my daughter like that. It's too embarrassing. The best I could do so far was leave a book on sexuality on her bed. On top of it I put a note that said: 'When you've read this, let's talk about it.'"

What exactly is it you should talk to your daughter about, Mom? Well, she needs to know how her body functions and how it will change at puberty. She needs to know about menstruation, of course, and that sex can result in pregnancy. (Don't laugh. Many kids don't understand that.) She also needs to know something about the male body and sexual drive.

Your daughter should have it clearly stated that premarital sex is against the law of God, and that there are physical consequences for breaking that law, such as pregnancy and venereal diseases, including AIDS (which so far is incurable). There are also psychological consequences, such as a damaged sense of self-worth. She needs to realize that the availability of birth-control methods does not change God's law.

Finally, she needs to know that you understand that remaining a virgin may be exceedingly difficult for her—that it will take courage, self-discipline, and conviction—but that she does have the right and the responsibility to say "No!" Mom, help your daughter accept the idea that God's way may not be the easiest way, but it is definitely the best way—in all things.

• Daughter... •

I can remember one time I was watching an old television re-run in which a girl said she was afraid she was pregnant. Her mother had told her that a girl could get pregnant by kissing a guy in the back seat of a Chevrolet if they were both wearing bathing suits! I remember thinking at the time that either the girl couldn't be too smart or the script was very outdated. Who would believe such a story today?

Thinking about it now, though, I'm not so sure. There are still some pretty crazy stories about how girls get pregnant. Maybe not that the stork brings a baby from the North Pole, but one girl once told me she knew someone who got pregnant from staying too long in the pool at a coed swimming party!

Some kids are getting an awful lot of sexual misinformation and need to be told the whole truth. Of course, I guess some mothers are embarrassed to talk to their daughters about sex. Maybe they think they're springing all this new information on their kids. Well, moms, it might interest you to know that your daughters usually hear about sex long before you tell them. You would be surprised at how young kids are when they start hearing such talk from their friends. The main problem is that their friends' information is usually wrong or, at best, incomplete.

So, moms, we are depending on you to give us the straight facts about sex. The sad thing is, not all of the crazy rumors are started by kids. Judging from what my friends have said, sometimes when moms have to talk

about sex to their children, they are too uncomfortable to tell them the whole story. So they use confusing terms and generalize about "morality," but leave a lot of important things unsaid.

One thing I want to stress to moms is that you really need to talk to your daughter honestly and at an early age. Well before puberty, tell her the whole truth in terms she can understand. A little honest information before she really needs it can keep her out of a lot of trouble later on!

• We Can Work It Out •

Here are some guidelines to help the two of you talk openly and honestly about sexual matters:

1. *Mom, don't wait until you feel really comfortable about broaching the subject.* You might wait forever. Do it now. Find a way to seek out your daughter's opinion on such sex-related issues as venereal disease (mention the AIDS film at school), the teenage pregnancy rate (ask about girls she knows who became pregnant), and abortion (comment on the recent TV special on the subject).

2. *Listen instead of arguing,* even if your opinions are so far apart that you are certain you will never be able to agree. Daughter, you may feel that some of your mom's ideas and opinions are hopelessly out-of-date. Mom, you may think that your daughter is naively out of touch with reality. But listen to each other anyway. Even if you never agree, exchanging opinions can help you understand why the other feels the way she does.

3. *Mom, you may find that your daughter already knows the biological facts.* It is up to you to let her know that the responsibilities of sex are every bit as important as the biology.

4. *Mom, if you absolutely cannot talk to your daughter about sex, go for the next best thing.* Helpful and informative books and tapes from a Christian perspective are available at Christian bookstores. If you choose this option, check out the content before you share it. Then let your daughter know you are available for questions and would welcome a discussion of the material.

If you need some help on this topic, you might want to read such books as: *A Love Story: Questions and Answers on Sex* by Tim Stafford, *Eros Defiled: The Christian and Sexual Sin* by John White (both of these written for teens), or *Sex Is a Parent Affair* by Letha Scanzoni. There is excellent help on the biological/physical aspects of sex in *1250 Health-Care Questions Women Ask* by Joe S. McIlhaney, a Christian gynecologist.

School Daze

13

Making the Grade

Long before Lisa reached her teen years, she went to see a doctor about a foot problem. Later we received an insurance form he had filled in. On the blank after "OCCUPATION," the doctor had written *Diligent Student*. He was right that her occupation was—and still is—"student." But just how "diligent" has fluctuated from year to year.

My response to Lisa's diligence, or lack thereof, has also fluctuated. At times I have been pleased and complimentary. At other times I have been quiet and understanding. And, though I hate to admit it, there have been times that I could best be described as a tiresome nag. The older Lisa got, the more impatient she became at the pressure I put on her about her schoolwork.

At one point, when for the hundredth time I was reminding her that "your grades are important to you,"

she replied, "Yeah, but not as important as they are to *you*." I had to think real hard about that one!

Differing opinions about the importance of school-work, especially grades, often present problems for parents and young people. While it is true that grades can reveal a good deal about your daughter's academic strengths and weaknesses, her work habits, and her chances of getting into certain colleges or ahead in the working world, there is a lot they cannot tell. They don't say anything about her worth as a person, for instance, nor do they speak about her likelihood of making a positive contribution to mankind. I'm sure even the most grade-conscious of parents would admit that character, perseverance, and integrity are as important as classroom performance, if not more so.

Some kids can get all *A*'s, others can barely manage *C*'s. Someone who could never fathom geometry can still be a loving, compassionate counselor to others. A girl who has no ability in French could eventually be a great math teacher. What is important is that all young people be encouraged to do the very best they can.

Many kids go through school never quite understanding "the system." This was true of Lisa's first year or so in high school. She tried her best to get along by watching others, and figuring things out, and second-guessing. She had a counselor available to her—and to five hundred other students—but she was hesitant to talk with him. She finally did, however, and now—because of his encouragement and guidance—Lisa regards him as the most influential person of her high school years.

Mom, nagging your daughter about her homework, school assignments, and grades is unlikely to do more

than make her angry with you. If you help her get organized, however, and let her know you are there to give assistance when she needs it, you can make the difference between failing and passing a course or between an average grade and a top performance. And your encouragement will let her know how much you really care about *her*, not her school performance alone.

Cindy is failing seventh grade. Her mom has scolded and cajoled, pleaded and reasoned, ignored and punished. Nothing has helped. "She just doesn't care," her frustrated mother says. "She's going to have to repeat a grade unless I can do something fast."

In the end, it is the student herself who has to take the responsibility for her work. There is a limit to what a mom can or should do. At some point all young people must learn that the decisions they make have consequences. In Cindy's case, the consequence will likely be repeating seventh grade while her classmates move on without her.

• Daughter... •

I admit that I have not always been what you would call a dedicated student. A *B* or a *C* seemed like a fine grade to me once. That's *average*, I thought, *so why strain myself trying to do better?* Now I know why—college. The better ones don't think that *C*'s are okay. I could have coasted all the way through high school, but that wouldn't have gotten me into the college of my choice. Luckily, I learned that in time to do something about it.

I'm not saying that I suddenly had to be a straight-*A* student and decided to devote all my time to my studies. But I did learn to plan my time a lot better. Without time management, I would not have made it into the fine college I now attend.

Patty, one of my friends, never really understood how to manage her time. She would work at her pizza-parlor job from the minute school was out until seven or eight at night. When she got home, she "relaxed" by talking on the telephone or watching TV until eleven or so. By the time Patty was ready to do her homework—if she did it at all—it was too late to get much done.

When test time came around, Patty would always say, "This time I'm really going to study and do well." I would always groan to myself because I knew what was bound to happen. Patty herself told me she would get home and sit down to study—for about ten minutes. Then she would get up and have a snack, read part of a book, watch a little TV, and call a friend. I gathered that—all in all—she studied about twenty minutes. But Patty would insist she had been at the books for hours. She didn't deduct all the time she spent *not* studying. Needless to say, Patty never did very well in school. The worst part is that she never understood why.

For me, the best thing to do about schoolwork is make a schedule and stick to it. When I was working in the afternoon or had some after-school activity, I had to be sure I allowed enough time for studying. If I expected to be busy at night, I did my homework in the after-noon. (Some kids might be able to get up a few hours earlier in the morning to do it, but this never worked for me.) When I knew way ahead of time that a test was

coming up, I tried to study a little while each night instead of cramming it all the night before. (I *tried*, but I didn't always succeed!)

Learning, after all, is the whole reason for being in school, and grades measure our progress. This doesn't mean that we can't have fun, too. We just have to schedule our fun and work so we have plenty of time for both.

• We Can Work It Out •

I think Lisa realized that achieving good grades is not the reason for being in school. The real purpose of schooling is to graduate educated young people who are well prepared for life. Grades are an important part of that process, in that they indicate several things: how well a specific skill or subject has been mastered, to some degree the level of the young person's discipline, the student's motivation and ability to set goals and attain them.

There are specific steps a mother and daughter can take to help the latter do her best in school:

1. *Daughter, be sure you understand what is required in each of your classes.* Also determine how to meet those requirements. This is *your* responsibility. Ask specific questions. (Lisa once had to redo a term paper two times because she didn't understand exactly how the teacher wanted the footnotes done.)

2. *Daughter, if you have a low grade, ask your teacher what you can do to raise it.* Is there extra-credit

work you can do? Did you miss any tests, papers, or projects that you can make up? If nothing else, your asking will let your teacher know you care about your grade.

3. *Daughter, learn how to learn.* Develop the skill of taking effective notes. Become test-wise—how to study for a test, what to expect on one, how to take different types. If you are having trouble, perhaps your parents can help. Or, for advice, ask a teacher, a friend who is a good student, or your school counselor. No matter how much you learn from a class, if you don't do well on a test, you won't get the credit you deserve.

4. *Together, set clear rules concerning homework.* When is it to be done? Decide on a time and stick to it. Where? Choose a quiet place where there will be no interruptions.

5. *Jointly accept the fact that in the end the student is the one responsible for the schoolwork.* That includes understanding what is required, completing it, and turning it in on time. Mom, confine your intervention to helping your daughter get organized at the beginning of the term. Then don't nag; leave her alone except when she asks you for help. (This is easy for me to say, but *so* hard for me to do.)

14

So *Many* Activities!

• Mother... •

Despite my good intentions, I was nagging Lisa yet again about her schoolwork. She looked me straight in the eye and asked in frustration, "Twenty years from now, would the fact that I made top grades in high school be important if achieving them meant I missed out on a lot of other things that would have made me a well-rounded person?"

I'll have to admit, it's been a long, long time since I thought about my own school grades. In fact, there are only a few of them I still remember. But just the other day I was telling Lisa about my experience on the school paper. And last night, as the music of H.M.S. Pinafore played on the radio, I sang along with every

song and told my kids all about the year I was in the chorus in our high-school production of that operetta.

These days I can regularly relax by playing the piano (though only in private!) because I took lessons for a couple of years when I was younger. My children have heard—regularly and more times than they care to remember—the story of all the things I learned at the job I had during my high-school years to save money so I could go to college. In the past few months I have also had occasion to draw on my teenage experience of teaching Sunday school to the children in a migrant workers' camp.

Twenty-plus years after high school, what do I most value today, and what has seemed most important in my total personhood—my academic achievements or my less book-related experiences? Take a guess!

Still, times have changed, and we're all different, so some things were easier for me to handle in school than they are for Lisa. Too, while there were extracurricular activities available to me, there were nowhere near as many as are offered to today's young people. Lisa is the kind of girl who is interested in just about everything. Like many other teens, she has a hard time deciding which activities to participate in and which to let go. And, like most parents, I still maintain that at this point in her life, school is her main responsibility.

Actually, I'm not asking her to choose between good grades and non-academic activities. I'm just asking her to plan carefully and wisely. That way she can have both.

• Daughter... •

Sports, clubs, youth groups, part-time jobs—these are only some of the activities open to us young people. But, as my mom is constantly reminding me, none of us can do everything. If you're like me, you probably find it awfully hard to choose—to balance the fun things with what you know your parents consider your "responsibilities."

My friend Anne couldn't choose. She wanted to be part of every activity that came her way. She had a part-time job at a local clothing store, was a cheerleader, was on the school track team, and was involved in the church youth group and choir. Anne had a lot of abilities and was a well-rounded person, but it was soon obvious that she had taken on more than she could handle. She had no time left for her schoolwork, her friends, or even for herself.

I can understand how Anne got herself so over-involved. We all need extracurricular activities. (I know *I* do.) They help keep us from going crazy from a routine and boring schedule or from the pressure of handling a tough course. Anne's problem was that she tried to do too much. A lot of us have the same problem.

Another friend, Nita, was the opposite of Anne. She refused to get involved in anything but her courses. Nita thought anything other than book learning was "school spirit," which she called silly and useless. Nita stayed away from football games, pep rallies, clubs, dances, or any other fun activity. As time went by, my friends and I saw less and less of her, except in class or

the library. By the time she was a senior, no one really knew if Nita still went to our school. She would duck in for her classes and be gone when they were over. I feel sorry for Nita. Though she always made the honor roll, she missed out on lots of good times.

I guess what I'm saying is that we have to choose our activities carefully. We shouldn't be like Anne and spread ourselves too thin. But neither should we be like Nita (as I sometimes think my mom wants me to be). We must try to find a good balance between school-work and other things. What worked for me was to start out each school year by making a list of all the activities that sounded interesting. Then I ranked them in order of their appeal and got involved with only a few at the top of the list. If one proved not so great after all, I dropped it. As I had time, I added more.

• We Can Work It Out •

We have been stressing how important it is for moms and daughters to work together to set down rules ahead of time in order to avoid last-minute conflicts. It's hard to do this, however, when it comes to specifying the number of activities in which a young person can participate. Something like cheerleading or an after-school job takes a tremendous amount of time and commitment, while an activity like French Club might involve no more than a lunchtime meeting once a month.

Rather than discussing the number of activities allowed, you both might want to focus on such questions as:

How much time does Daughter have to devote to activities?

Who is to say how much time is too much?

Which activities are most worthwhile?

Which are most enjoyable?

Once a tentative selection has been made, Daughter, you might want to evaluate your choices by asking yourself the following:

Will these activities expose me to *different* kinds of experiences (not "all sports," for instance)?

Will they surround me with the kinds of people who will build me up and help me develop different areas of my life?

Will these activities complement my family life and my family's schedule?

Which activity will I give up if my schedule gets jammed?

Mom, it may be that you (like me) put more of a premium on schoolwork than your daughter does. Let her know that if her grades drop, she will have to cut back on other involvements to give her more study time. As you discuss your guidelines with your daughter, here is an old slogan for both of you: "Everything in moderation." It still works!

15

Which Classes Are the Right Ones?

• **Mother...** •

In school, Jeannette wanted to concentrate on art, literature, and social studies. Her parents insisted she sign up for advanced math, chemistry, and Latin. "The classes you want are just playtime," they told her. "Take real courses. You'll thank us for it later, when they help you get into a good college."

She never did. In fact, she did so poorly in the classes her parents chose for her, she barely graduated from high school. Her parents suggested community college, but by then Jeannette had developed a strong dislike for school and refused to even consider it.

Looking back, Jeannette's parents concede they made a mistake. Still, I can understand their concern about their daughter's coursework. Several times I shuddered when I heard Lisa discussing the classes she

wanted to take. Most of the electives were art-related. "You'll have lots of time for fun classes later," I would tell her. "In high school you need to *work!*" She convinced me other subjects besides math, science, and language could help prepare her for college and also be acceptable to admissions boards. She was right. Lisa is now an art major in college.

Through junior high, there are usually not many elective courses open to students. It's in high school that most kids get their first taste of self-determination in their education. There are some basic graduation requirements, of course, but because of the number of other courses to choose from, many students are bewildered at first. Though most schools give guidelines and suggestions and provide counselors to help a student build a solid course of study for specific educational goals, the final decisions are left to the students. Your daughter will probably appreciate your help, Mom, especially if you are sensitive to her interests and long-term goals and take the time to acquaint yourself with the courses that are required or suggested for various high-school programs (such as college-prep or business ed.)

More and more, schools are stressing the importance of turning out well-rounded graduates who have had a balanced education. Most colleges look for that, too, just as it is probably *your* goal for your daughter. Encourage her to take a variety of classes—to balance math with art, history with a cooking class, English comp with a foreign language. But always listen to her preferences. Our daughters want to be heard, and they don't want us to make choices for them.

• Daughter... •

Christy never did a good job of choosing her classes. In her sophomore year of high school, her four electives (out of six courses) were work ed, cooking, child-care, and painting. By the time she was a senior, Christy was struggling to get in all the credits she needed to graduate. When most other seniors had already fulfilled their requirements and were taking it a bit easier, she was working harder than ever. Christy had once talked about going to college, but when she saw how many high-school courses she would need to qualify, she gave up and eventually went to work as a checker in a grocery store. She never gave herself a chance.

Easy electives and fun classes are great as a sideline, but they don't always count for much in the big picture. Schools require a certain number of units of study for graduation, most of which cannot be filled by elective classes. More importantly, courses in such demanding areas as math, science, and foreign language are required if you want to be accepted in an accredited college. Solid subjects not only prepare us for college, but also for jobs and for life in general. Skills in fields such as music, child-care, and woodworking can be picked up later, whether or not we go on to college.

Still, electives can be enjoyable and also be learning experiences. They don't have to be a waste of time. My friend Michele never understood this. Her schedule was filled with tough courses like calculus, physics, and college-level English. I think Michele would have enjoyed a few of the lighter subjects if she had ever tried them.

How do you know what classes to take? If your parents are like mine, they probably think they are your best advisors. Actually, school counselors and teachers know the requirements for graduation and college entrance better than most parents do. Parents' information tends to be based on their own experience, which is out of date. It was my high-school counselor who helped me more than anyone else. But he didn't come to me with a lot of suggestions. I had to go to ask some questions and listen to his ideas.

Our school offers a four-year advisory set-up that helps students plan ahead what courses to take each semester of the four years. That scheduling kept me from having to cram in extra classes at the last minute or having to take summer school before my senior year. Your school probably has such a system, too.

Actually, my parents did offer some good advice about coursework in general. They had been through it before and had insights I didn't have. But things have changed since our parents were in high school. Sometimes they think they know how things work now—and they don't. It's a good idea to check out their academic advice with teachers or counselors.

• We Can Work It Out •

Mom, if you want to have some input in your daughter's schedule, tell her so. Don't just assume she will consult you. Take the initiative and let her know you would like to help her work it out or at least be kept

informed about what courses she's planning to take while in school.

It's a good idea to sit down together before the first year of senior high school and lay out a tentative four-year course plan (or three-year). *Tentative*, remember. Ideas, interests, and even graduation requirements may change. Before you start, also acquaint yourselves with the requirements for college- or trade-school entrance so that options for higher education are kept open.

It could be that the two of you will have trouble reaching an agreement on some courses. If you come to an impasse, or if you just need another opinion, ask for help—from a teacher, a high-school counselor, or other adults who seem to know what is current in the educational field and workplace.

16

College? If Not, What?

• Mother... •

From the time Lisa was born, her father and I assumed she would go to college. It was the same for the parents of three of Lisa's best friends. After graduation, Lisa and Karen cleared all the necessary hurdles and landed in college, but Susan and Christine chose other paths.

College is not a young person's only option, nor is it the best choice for everyone. Susan seemingly zipped through high school, and she always got good grades. Though she applied to and was accepted by several colleges, by graduation day she was dreading the thought of rushing off to another school situation and more studying. She decided she needed a break. "In time I'll probably go," Susan said, "but not right away. I

want to travel some, then maybe get a job and work for a while."

Christine, on the other hand, never liked school. Several times she considered dropping out. "By the time I was a sophomore, I'd had enough," she admits. But she hung in there, working just hard enough to graduate. By then, college was not a feasible consideration.

Regardless of what *you* want, Mom, by the time your daughter graduates from high school she is old enough to make her own decision on which direction she wants her life to go. She also has to accept the responsibility for that decision. But if you continue to nag, you may end up pushing her into doing the exact opposite of what you want, even though she might otherwise have eventually agreed with you.

One problem with which many of us parents have to struggle is the tendency to expect—sometimes even demand—that our daughters will fulfill our dreams or live out our missed opportunities. We have no right to set up such pressures. Our daughters are entitled to dreams of their own.

• Daughter... •

Long before I started high school, my parents were already talking about college. I figured I would go some day, but it seemed so far off I got tired of hearing about it. As I came closer and closer to high-school gradua-

tion, I began to feel differently. I realized I was facing the end of an era. What would come next? There were so many options to consider.

A high-school graduate can (1) get a full-time job; (2) study for two years at a community college (perhaps going on to a four-year college afterwards), (3) get some "technical" training; or (4) begin a four-year college. I had friends who represented each of those options.

Some kids finish their senior year of high school and find themselves completely burned out. This was true of Susan, so she decided to take a break from school for a year. She is now working full-time and saving money for her college tuition but is also hoping to do some traveling. Her parents have supported her decision. "When you do start college," they told her, "you will really be ready."

Christine, too, is not now going to college, and she doesn't plan to do so in the future. She says it just isn't right for her and is now debating between attending a trade school and continuing her full-time job. I wouldn't want to be doing that, but it's Christine's decision—and it might even be right for her, all things considered.

Karen definitely wanted to go to college right away, but she wasn't sure where to go or what to study. Her decision was to start her higher education at a community college. She can go there for two years at minimal cost and will get many of her basic college requirements out of the way. After two years, she is planning to transfer to a four-year college and work toward a degree in whatever field she has decided upon.

I chose to live in a dorm at a four-year liberal arts college two thousand miles away from home. I know I

may be biased, but I think there are a lot of advantages to such a college, including living away from home. Besides a great education, it offers many extracurricular activities as well as new experiences, friendships, and learning to live with a roommate and others in the dorm.

Your decision might not be the same as mine. That's fine, but be sure to look at your options and talk them over with your parents. Listen to what they say and consider their suggestions. In the end, the decision is yours—but you also are responsible for living with its consequences.

• **We Can Work It Out** •

Let's begin here with the assumption that parent and teenager agree that Daughter has the final say in what she will do after graduation, but that Mom has the right to state her opinion and her reasons for recommending a particular plan.

To help you make a wise decision, Daughter, here are some things for you to consider and discuss with both parents.

1. *If you don't want to go to college, come up with an alternate plan.* Are you going to work? To travel? Or just take life easy? Remember that your parents have the right to decide under what conditions you can continue to live at home for free! As you consider your decision you might ask yourself, "What are the short- and long-term benefits and consequences of my decision?

2. *If you decide to work, will you be able to support yourself?* Consider where you will live and list other expenses you will have. Make out a budget so you can see where you stand financially; then have your parents review it with you to see if it is realistic. As old pros at this business, they'll make sure you don't forget such items as telephone, laundry, car expenses, and much more.

3. *If you quit school, it will be hard to go back later on.* Most kids who decide to wait for a year or two never do return to school.

4. *If you decide to take a break before college, it will be easier to go back if you continue to read and learn on your own.* You might even enroll in an evening course at a community college, even if it's just for fun.

5. *If you decide to delay further schooling, be sure you have a good reason for doing so.* If it's just because you are worried about making the transition, understand that any new venture requires adjustments for everyone. And the longer you wait, the greater the adjustment will be, partly because you will have gotten used to the feeling of independence that comes with earning some money.

Keep your mind and options open. Before graduation day, your ideas may change. The next few years can be some of the greatest in your life if you make some wise choices.

All in the Family

17

Sibling Rivalry

• Mother... •

I remember from my own school days that sixteen-year-old Beth and her fourteen-year-old sister, Judy, were more than "not friends"; they acted like sworn enemies. When they passed in the halls at school, neither would speak to the other. "It's just ordinary sibling rivalry," their mother told mine with a sigh of resignation. "They say they hate each other, but I know they don't really. The time will come when they'll realize how much having a sister means."

Twenty-five years have passed, and Beth and Judy still don't acknowledge each other's existence. "I can't understand it," their mother says now. "Why do they resent each other so? We've always treated them exactly alike."

Maybe that's part of the problem. Beth and Judy are not at all alike, and they never were. As they were

growing up, Beth was adventurous, athletic, outgoing, and always testing the rules. Whenever she acted irresponsibly, the rules were tightened for both girls.

Judy, a studious introvert, was shy and somewhat unsure of herself. To encourage her to make friends, her parents put together parties and other activities that both girls were expected to attend. Beth loathed the stiff, organized sessions that always seemed to interfere with her own plans. And she resented her parents' insistence that she include her younger sister in her own social life. Judy was not happy about it either, since she felt uncomfortable enough about being with people without being pushed.

Because Beth enjoyed sports, Judy was pressured to participate in athletics, too. Judy despised it and never did well. Meanwhile, Beth's average grades were constantly compared to Judy's A's. "If you'd just work harder, you could do as well as your sister," her parents would scold. All things considered, no wonder the girls hated each other!

No two people are alike, not even identical twins. Proverbs 22:6 speaks of the duty of parents to train each child "in the way he should go," and there are also other biblical references to indicate that kids deserve to be respected, loved, and appreciated for who they are. That means being treated in accordance with their own abilities and behavior. (See, for example, 1 Cor. 7:7b; 1 Peter 4:10.)

Even if parents do everything wisely and with sensitivity, there will undoubtedly be some sibling conflicts. It's perfectly natural for brothers and sisters to have territorial struggles and arguments: "He won't stay out

of my things," "Just because she likes it doesn't mean I have to," "Why do we always have to do things *her* way?"

How much competition arises between siblings, whether or not their personalities are compatible, how many comparisons are made between them (a certain amount is inevitable)—these are things that help determine how extreme the sibling rivalry will be in a particular family. Some of these factors we parents can control. Others we can't.

• **Daughter...** •

Sometimes it's hard to put up with brothers or sisters. No matter where you stand in the family, you often feel you've got the short end of the stick. Older kids are certain that their parents are extra hard on them and easy on the younger ones. Younger children think they get bossed around by their siblings and treated like babies by their parents. The middle kids may feel that no one ever notices them at all and that they're always taken for granted.

There are specific problem situations, too. My friend Wendy and her brother Zack have never really gotten along. Wendy thinks that Zack gets away with "everything." He was born with serious physical problems, so everyone tried really hard to keep him happy right from the start. He's better now, but he still rules their household. Wendy is always complaining about Zack's getting into her makeup and art supplies. Her parents see

nothing wrong with what he does. In fact, they call Wendy picky because she doesn't want him in her room or touching her stuff. It's not good for Zack to always get whatever he wants, and Wendy should be able to protect her possessions and her privacy.

With Wendy and Zack, there is more than simple sibling rivalry involved. Their parents need to understand that Wendy has the same rights as Zack and is entitled to equal consideration. Sisters and brothers always fight over their own space. Parents need to understand this and not take sides with one kid to the detriment of the other(s).

It is terribly important that parents not show favoritism with their children. We know one family situation that was really unfair. The father wasn't around very much, so that left just the mother, daughter, and son. The mom and the daughter would always gang up on the son and tell him he was stupid, lazy, and good-for-nothing. Since no one was there to defend him or tell him otherwise, he started to believe them, and soon that's how he acted.

Because most teens are pretty insecure, we need our parents to help build us up instead of tearing us down. Moms, don't compare us with our brothers and sisters. Don't tell us, "I wish you got good grades like your sister." Or "Danny is so much more athletic than you are." Don't label us and say such things as "Johnny is the smart one, Ben is the quiet one, and Jan is the cute one." Appreciate us for who we are, not for what we can or cannot do—especially as compared to our siblings (or anyone else).

My parents have always treated my brother and me pretty fairly. As a result, we've never really been in

competition or felt much rivalry between us. I guess the hardest time was when I started junior high and he was in fourth grade. He still wanted us to play together like we used to, but I wanted to be considered more grown-up and not be "bothered with that little kid" anymore. It was hard for both of us, I guess, because I sometimes missed some of the fun things we used to do together.

As teens, we need to try to be sensitive to our brothers' and sisters' needs. It's sometimes tempting to do things to spite them, but maybe it would work if we set an example by being thoughtful—like not blasting music early in the morning when they're still asleep. If they're neatniks and we're slobs, it's only fair that we try to keep our junk in our own territory. In the end, I guess the best defense against letting sibling rivalry spin out of control is for family members to treat each other with the same kind of consideration shown toward friends.

• We Can Work It Out •

To help keep sibling antagonism to a minimum, trying establishing a set of "rules for respect" in your family. The following suggestions will get you started.

1. *Don't give each other labels.* Leave each one free to demonstrate his or her own strengths without being prejudged. Then appreciate all members' individuality—who they are in their own right.

2. *Treat each other courteously.* Kids should not be allowed to belittle or put each other down or to call

each other names. It is the job of each family member to build up and affirm the others, to strengthen each other's self-image.

3. *One kid should never be allowed to hit or bully another.* Parents should make it clear that physical abuse or persistent teasing will not be tolerated.

4. *Mom, don't compare your children with each other* (and don't allow them to do it either). Encourage all members to appreciate each other for their strengths—what they are, rather than what they are not. If one says, "Why can't I do what Janet did?" answer, "Because you aren't Janet. She does some things better than you, and you do some things better than she does."

5. *If things get out of hand, Mom, don't resort to empty threats* ("If you don't stop this minute, I'll throw you both out!"). That will tell your kids only that you have lost control; it won't teach them a thing!

18

"Don't Embarrass Me!"

• **Mother...** •

"How do you know you won't like being on the soccer team, Lisa?" I pressed. "You haven't even tried! There are a lot of nice girls on that team."

"But I don't *want* to play soccer!" Lisa shot back. "It made me uncomfortable when you asked the coach about try-outs. Anyway, I want to be on the drill team."

This argument had been going on for close to a week. I knew that Lisa looked longingly at the sophisticated routines performed by the popular girls on the junior-high drill team. (My impression of those girls was that they were being pushed into growing up too quickly.) She admired the brightly colored, sequined outfits they wore. (I saw outfits too skimpy for junior-highers and with far too high a price tag.) On the other hand, I saw the advantages of participating in a team sport like soccer. (She saw the drudgery of playing a game she

didn't really care about.) I saw "a nice group of girls" I wanted Lisa to get to know. (She saw kids she was sure couldn't begin to measure up to the drill-team girls in a lot of ways she thought important.)

"You're just against the drill team because your friends are always putting it down," Lisa accused. Even as I opened my mouth to protest, I knew that she was at least partly right. Some of my friends talked openly about the questionable values of glamour, glitter, and fierce competition instilled into those thirteen- and fourteen-year-old girls. How would it look to them if *my* daughter joined the team?

"You're starting to sound like Janna's mother," Lisa informed me in a tone that sounded very close to disgust. "She's always interfering in Janna's life."

Janna's mother? She was one of the most outspoken critics of the drill team, although I always suspected that was at least partly because her daughter failed to make the team. While Janna's mother was pleased with her daughter's varied accomplishments, she was never really satisfied—and was pretty outspoken about that.

"Janna's on the soccer team," Lisa reminded me. "If I join, you'll probably do exactly what the kids say *her* mother does. You'll come to the away games as a bus chaperone, then cheer and holler and jump up and down to embarrass me. And all the way home you'll nag about how I can improve my playing."

That made me stop to examine my motives! How much of what I said I wanted for Lisa was what I really wanted for myself? Certainly we mothers have a right to expect our children to behave considerately and not embarrass us with their rudeness or bad manners. But we don't have a right to use them for our own purposes,

and that includes making us look good in front of our friends. And we certainly should keep in mind that some of the things we do and say can embarrass our kids—which, I think, was what that soccer discussion with Lisa was really about.

• Daughter... •

Parents can sometimes make their kids pretty uncomfortable. I'm usually proud of the way my folks act, but Donna has always been embarrassed by hers. They are both very overweight and don't seem to care how they look. They hardly ever talk to anyone, at least that's what Donna has told us. Donna's mom dresses out of style and never wears any makeup or does anything to her hair. From the minute he comes home from work until he falls asleep, Donna's dad sits in front of the television. Donna says that if she tries to talk to him he tells her to wait for a commercial. Donna has gotten to the point where she hardly ever goes home. And she never invites friends or dates to her house. She says she is just too embarrassed by her folks.

We've all had experiences when we've been embarrassed about our parents. For example, I really love my dad, but the way he treats waitresses in restaurants makes me uncomfortable. He's always making them run around to get all kinds of things he wants and to take back anything that isn't perfect. It makes me feel as if everyone is staring at us, and I want to disappear.

So what can we do when we feel embarrassed about our parents? Well, first, I guess we need to realize

that a lot of the things that embarrass us so much are probably going completely unnoticed by the people around us. But, even so, I think we should talk to our parents about the things they do that make us uncomfortable. We don't have to condemn, just suggest. They probably don't even realize they are doing those annoying little things.

We also have to remember that sometimes our parents are pretty embarrassed by how *we* look and act. Because they're not accustomed to all the new styles and fashions we like, they probably think that some of the clothes we wear and some of our hairdos and make-up styles are pretty strange.

I knew a family that was conservative about most things and downright old-fashioned in a few areas. When one of their daughters suddenly went punk—cutting her hair spiky and short, wearing lots of dark makeup and all black clothes—her mother was horrified. She was so embarrassed by her daughter's appearance, she refused to be seen with her in public.

• We Can Work It Out •

Our goal as mother and daughter should be to learn to accept and love the other as she is and for what she is. Every parent has weaknesses. So does every child. The challenge in a family is to respect and appreciate each member's unique contributions and tolerate the harmless but sometimes irritating traits we all have.

Mom, resist the temptation to try to press your daughter into the mold you have prepared for her. Be

sensitive to her desires, abilities, and interests by re-specting her right to be "different." Daughter, if you feel your mom is trying to relive her teen years through you or remake you into someone you are not, talk to her about it. Let her know, too—in a kind way—if there are certain ways she acts that sometimes embarrass you. By the way, it might be easier to get your mom to accept your styles if you try to ease her into them. Try not to be too drastic right off.

If either of you thinks a few friendly suggestions would help the other make some positive changes, go ahead and suggest. Just be careful that suggestions don't turn into accusations and criticism.

19

The Changing Family Unit

• Mother... •

"We cannot even begin to work on what the media would call our relationship problems," Sydney says. "My daughter Tara and I have no relationship and no conversation. We are merely two people sharing the same house."

"We have nothing to talk about," Tara insists. "When I want to talk, I phone my dad."

Sydney and her husband were divorced when Tara was ten years old. That was five years ago. Since then, mother and daughter have done little else but fight. "She says it was my dad's fault they split up," Tara says, "but I'm sure it wasn't. She was to blame."

Marsha has three daughters. The middle child is hers by birth, the other two by marriage. "I went into my

136

second marriage with no qualms about the girls, any of them," says Marsha. "We all got along so well before. But since the marriage, things have gone straight downhill. I don't know why, or whose fault it is."

The American family is changing in many ways, including its makeup. Before long, the experts tell us, families made up of a mother and father and the children born to them will be in the minority. There is a growing number of families affected by divorce—single-parent families, and blended families with stepparents and stepchildren. Not only are these family units affected by the usual conflicts and stresses between parents and teens, they have a whole additional set of concerns.

You may be part of such a fragmented family. If so, you probably already know that it requires extra commitment to work out your difficulties, to understand each other, and to show patience and consideration. Without exception these challenges require first of all that you keep the communication channels open.

• Daughter... •

Statistics say that one out of every two marriages will end in divorce. Maybe that's high for Christian families, but we get the point. Divorce is a big problem nowadays, and we young people think about that, even if our own parents are still together.

In many divorce situations, kids are hit the hardest. They get moved from parent to parent, from house to

house, town to town, sometimes state to state. They seem to lose out in so many ways, most often in their relationship with one parent.

Allison's parents were divorced when she was very young. Since then they have both remarried. Half the time, Allison lives in one house with her father, step-mother, and sister. The other half of the time, she lives in her mother's household, which includes a stepfather and two stepsisters. Allison has gotten used to the situation, but she admits it can be terribly awkward. For one thing, her friends never can keep track of which house she is living at. And it is really inconvenient having half of her things at each place.

There seem to be a lot of myths about blended families. The new groupings never seem to work as well as "The Brady Bunch," but they're not as terrible as the stories about Cinderella and Snow White either. Most of the time, it seems that "second families" are pretty much like other families, except with extra problems.

Soon after Stephanie's parents divorced (the third divorce for her mother), her mother was dating someone. Several months later, Stephanie had a new "father," actually her fourth one. All of Stephanie's stepdads were in and out of her life so quickly that she never really had the chance to get to know any of them. Stephanie says she's never really had a father at all.

Lynn, on the other hand, has had a wonderful father, actually, a step-father. Her parents' divorced when she was only two years old. Her mother remarried after two years, and her new husband has been wonderful for Lynn. If you ask Lynn about her "real father," she'll tell you she's living with him now. She says that he's the

only father she has ever really had, and the only one she ever wants.

If a parent's death or a divorce and remarriage changes your family life, don't assume it won't work out. Chances are it will. Just determine to cooperate and work on building some strong new relationships in the new situation. No doubt, some of your friends have also faced a family breakup for one reason or another. It will probably help to talk out your concerns with them.

• We Can Work It Out •

If you are in a family that has gone through divorce, you might want to consider the following suggestions:

1. *Mom, regardless of what you think of your former husband, be careful not to run him down to your daughter.* She is probably more aware of his weaknesses (and yours, too) than you realize. Reminding her of them may put her in the position of having to defend him. It is unfair of you to undermine your daughter's relationship with, and love for, her father.

2. *Daughter, you can't possibly know all the reasons behind your parents' split, so don't place the blame on either one.* The causes of divorce are many and complicated and almost always two-sided. Very seldom is either person totally at fault. Do your best to stay neutral.

3. *Mom, be honest with your daughter about how painful divorce really is.* Let her know that it is not an easy way out. And while you are sharing your hurt, be sure to acknowledge her pain, too.

4. *Mom, assure your daughter that the divorce was in no way her fault.* It may seem illogical to an adult, but many kids are convinced they are responsible for their parents' breakup.

5. *Daughter, you may have to accept more responsibility at home than some of your friends do.* But that isn't all bad. With the added responsibility can come greater maturity.

6. *Mom, continually reassure your daughter that you love her, and encourage your ex-husband to do the same.* Determine not to cut him down or drive a wedge between him and your daughter. You divorced each other, not your children.

7. *Commit to work together to make the best out of your family situation, whatever it is.*

Mom, if you are facing, or have gone through, separation or divorce, be encouraged to know that single moms and their daughters often enjoy an especially close relationship. It may be so with you.

Stepmom, your problems will be different. Whereas you were once strangers, perhaps gradually even friends, you are suddenly "mother and daughter." You can build a happy and healthy relationship, but you will have to work at it. Here are some suggestions that especially apply if your stepdaughter lives permanently with you and her father:

1. *You're too old for storybook relationships.* Forget Cinderella and Snow White. Forget "The Brady Bunch," too. Real live people take a lot longer than half an hour to work out their problem, but they don't unnecessarily prolong a cold war either. Accept and appreciate the other's individuality and respect her opinions.

2. *Show your affection for each other.* Don't be stingy with words of praise and gestures of appreciation. If you can manage it, be generous with hugs. If you are feeling no affection, make an effort to find one thing about each other to compliment each day.

3. *Take a genuine interest in each other's activities.* I know, I know—you don't care about needlepoint, Daughter, and that's all your stepmom does. But couldn't you ask how her current project is going, then take a few minutes to look at it? You may know nothing about track, stepmother, but if your husband's daughter is into running, could you make the effort to take in some of her meets?

4. *Stepmom, show interest in your new daughter's schoolwork*—her subjects and her accomplishments. Let her know you support her and are ready to help her in any way you can. But don't overdo it. And don't nag!

5. *Do things together that you are both interested in.* Go shopping, perhaps, or make chocolate mousse for dessert, or wallpaper the daughter's bedroom.

6. *Decide together the ground rules for your family life, as well as the penalty of breaking them.* It will be harder for the two generations in a blended family than for moms and daughters who have always been together. Stepparents are probably used to doing things differently. Likely you will all have to do a good deal of bending and compromising. Be sure both marital partners agree on who will have the final say about discipline.

7. *Stepmother, when discipline is needed, be firm and consistent, yet fair and loving.* Let the children know that whatever happens, they can depend on you to stand by them.

8. *Allow yourself to be vulnerable.* Shared laughter and shared tears are like cement—they can bond you together for life.

9. *Guard against undermining the affection and loyalty your stepchildren feel toward their natural mother,* as closely as you respect the positive feelings your natural children have for their father (whether he is divorced from you or deceased).

20

Strained Relationships

• Mother... •

Disagreements and conflicts can happen even when things are going pretty much the way they should between a mother and daughter. Some friction is normal, but certain misunderstandings and disharmonies can threaten to destroy the entire relationship. Even temporary difficulties can cause deep, painful wounds.

"Mom's role playing is my biggest problem," says fifteen-year-old Melissa. "She dresses like a teenager and tries to talk like we do. Mom tells everyone, 'Melissa and I are best friends.' She tells me, 'Everyone thinks we're sisters.' Well, she's wrong. What everyone thinks is that she's a middle-aged woman who acts like a kid." After a pause she adds, "Why can't she understand? I don't want an overaged friend. What I want is a mother."

Moms and daughters should be *like* friends in their consideration for each other's feelings. They should be companionable when that is suitable. But first and foremost, they should be mother and daughter.

"Questions, questions, questions," Tina complains. "That's all I get from my mother. She says she's interested. I say she's just plain nosey."

"She used to tell me everything," Tina's mother says. "Now she confides only in her friends. Why? I've always listened and tried to understand."

When they become teenagers, our daughters change, and so do our relationships with them. Suddenly we are no longer the central figure in their lives. Things between us become more complicated, harder to understand. But all this is a normal move toward independence—necessary and healthy.

"My mom tries to run my life," Tracy complains. "She wants to make every decision for me." Her mother responds with a smile and a shrug, commenting, "I know what she means, but kids always think their moms try to run their lives."

With our teens locked in a struggle to form their own identities, we moms need to be alert to just where it is appropriate for us to pull back and let our daughters be themselves. Unfortunately, we can't always take their word for where that freedom line should be. They are new at this independence game and may not recognize the warning signs.

Remember, Mom, that things may not be as bad between the two of you as you think they are. It is hard to be objective about any close relationship. You may want to discuss your concerns with an impartial third

party, perhaps a teacher or your husband (although he may not be objective either) or the parents of one of your daughter's friends.

And there's more good news: the teen years will almost certainly be the stormiest time the two of you will ever have together. It will get better! Many problems will automatically be resolved once a mom is able to look at her daughter as a young but responsible adult instead of a child.

• Daughter... •

Crystal talks a lot about her poor relationship with her mother. "It seems like I can't talk to her at all anymore," she says. "Everything I say she treats as an excuse to yell at me. Any skirt I wear is too short, all my makeup is too dark, and none of my friends is ever good enough. I try to avoid going home as long as I can. It seems like my mom just doesn't want me around much.

Crystal's situation at home was pretty unsettling. But, as it turned out, her mom wasn't the only one to blame. When Crystal felt unfairly pressured by her mother, she reacted by tuning out everything she said. If they tried to talk to each other, things might have been much different.

Strained relations at home can cause a lot of pain for everyone concerned. Sometimes at school my friend Gretchen would say she dreaded going home. Like Crystal, Gretchen didn't get along with her mom. They

were always picking on the other's faults and completely ignored each other's strong points. In this case, instead of Daughter's turning her back on what Mom said, she fought back with a lot of accusations of her own.

Strained relationships aren't always caused by mutual criticisms or apparent indifference. Sometimes the problem is trying to get too close. Take Melissa (whom my mom already mentioned). When Melissa was little, her mother worked full-time, so Melissa was always stuck with a baby-sitter. I guess her mom feels guilty about all the time she missed being with Melissa, so now, years later, she's trying to make up for it. She wants to be Melissa's best friend and do everything with her. Melissa hates feeling smothered by all that attention.

The real problem is that Melissa's mom doesn't seem to realize there is anything wrong. Melissa never says anything to her about it, but she sure does complain to us. Just like Crystal or Gretchen, Melissa and her mother never really talk. I guess the answer is, whatever problem is going on between a girl and her mom, it won't be cleared up unless it's brought out into the open in a civilized way.

• We Can Work It Out •

When Mom wants to be best friend instead of parent, or Daughter pulls the silent act because she resents what she sees as her mother's intrusion, or there are loud arguments because Mom won't let Daughter run

her own life—there can be big problems. But not insurmountable ones.

There are as many possible problems as there are mothers and daughters. Your conflicts may be different from anything we've looked at. But whatever the basis of your struggle, you need to talk about it with each other. Politely say exactly what it is that's bothering you. If you don't, the other person may think everything is fine, when what is really happening is that the barrier between you is growing higher and higher.

Daughter, if you find it difficult to talk to your mom about your mutual hostilities, why not start out by telling her about your friends' problems? It will be easier for you to talk about difficult topics in that hypothetical way and thus encourage her to listen without criticizing and judging.

Mom, as you begin to open up with each other, even if your relationship is so strained that you seem to be doing nothing but argue, make a list of the areas on which you *can* agree. Focus on them. Look for "safe" activities you can do together, such as aerobics, television, shopping, cooking, reading this book aloud. Promise each other that when you are doing these things you both enjoy, there will be no arguing, nagging, or criticizing. That might clear the air enough so that you can later exchange "pet peeves" in a loving way.

Daughter, if your basic complaint is that you are feeling smothered by your mom, tell her so as positively as you can. You might say something such as, "Mom, I love you very much but I need more time with my friends." Show her that putting distance between the two of you doesn't mean you are rejecting her

completely. She will be much more understanding if you leave time to do things with her, too.

Understand that conflicts and differences of opinion are all right. They don't necessarily mean you don't love each other. What is not all right is refusing to work on them—because that means you are giving up on that precious mother-daughter relationship.

21

Selective Discipline

• **Mother...** •

Long ago Carrie gave up trying to control her seventeen-year old daughter's behavior. "It's just not worth the hassle," she insists. "Let Cathy do what she wants. She knows right from wrong by now, and she's got to take responsibility for her own mistakes. I just hope she'll turn out all right."

It's not that Carrie's daughter is a bad kid. It's just that Carrie has grown tired of all the arguments about what was allowed. "I'd set a rule," she says, "but Cathy would argue and argue until I wore down and told her to do what she wanted. So what good was the rule? Two years ago I gave up trying."

All young people need discipline. Our goal as parents is to guide them to maturity—to where they know themselves, accept who they are, control their own behavior, and are able to use their abilities constructively.

Unfortunately, it is usually only *after* we have reached the boiling point that we confront our teenagers with the things that are bothering us. Then we find ourselves on the offensive, acting out of exasperation. But, to be effective, discipline must be an expression of love not anger or fear.

Mom, you already know that it isn't always possible to discipline without creating some alienation and resentment in your daughter, at least for a while. Instead of looking at her unhappiness and your frustration, consider the future. Carrie says she hopes Cathy will "turn out all right." The chances of that happening would be much better if Carrie had not abdicated her parental responsibility so completely and prematurely.

• Daughter... •

"Do you realize what time it is? One in the morning! You know you were supposed to be in by eleven-thirty! Where have you been?"

"Mom, I'm sorry. We were all at Karen's house talking and we just lost track of time."

"That's no excuse! You could easily have called and told us where you were or that you were going to be late. We were worried sick! This has happened way too often. You can expect some consequences for your actions!"

That dialogue represents something that has happened to me several times. It was so easy to lose track of time or forget my curfew when I was having a good time with my friends. But my forgetfulness started

getting out of hand. The consequence that came my way was being grounded. For two weeks I couldn't talk on the phone, go out with friends, or have dates. I hated it, and I was so mad at my parents. But I did learn my lesson. From then on, I was more careful to watch the time. So I guess the punishment served its purpose.

Teenagers hate to be punished. And it's pretty hard to be philosophical and understanding while the punishment is going on. Sometimes it seems so unfair, even though parents always say, "I'm not doing this to hurt you, but you have to learn your lesson." Then they add, "I'm just doing this for your own good," but we're not perfectly sure that's true.

Actually, my parents are usually pretty reasonable when it comes to discipline. They've never grounded me from anything really important to me or made me miss a once-in-a-lifetime event, and I've never been grounded for extra-long periods of time. In return, I try to be reasonable with them. When they lay down a punishment, I try to accept it gracefully—and then follow the guidelines more carefully in the future.

• We Can Work It Out •

For discipline to be effective, it is important that both generations know what to expect. You have already set down your family rules. But have you also decided what will happen should those boundaries be crossed? Perhaps the following suggestions will help you set down some disciplinary principles:

1. *As a child grows and matures, parental methods of discipline need to change.* Mom, if she complains, "You treat me like a child," she may be right. Ask her for specifics and negotiate some possible revisions.

2. *Where specific rules are concerned, the consequences for breaking them should be clear.* ("If you come in late, your curfew will be earlier the next night.") Be sure the punishment fits the crime. Some parents are tempted to declare a blanket penalty ("If you do *anything* wrong, you're grounded for a week"). It may be easier, Mom, but it isn't fair.

3. *Mom, be consistent.* If it is decided that breaking a rule carries a certain penalty, that penalty should be carried out. There should be an understanding that arguing, pouting, begging, or bargaining will not change it. Neither parent should rescind a ruling made by his or her spouse.

4. *Allow for some flexibility.* For instance, might Daughter's curfew be extended if she calls to explain why she needs extra time?

5. *The way to successfully mete out discipline is with a healthy portion of love.* Only when it is so cushioned does punishment bring about the desired results.

6. *Daughter, no one expects you to enjoy punishment*—even though you helped set up the guidelines. But if you accept its necessity and cooperate with the terms, you will learn from it, and the times of discipline are sure to be less frequent, shorter, and less severe in the future. That's good news, isn't it?

P·A·R·T
SIX

Building
Sound Values

22

Morals and Value Systems

• Mother... •

"With teenagers, the less said the better," advised Barbara, mother of three teens. "The only way to keep from arguing with them is to stick to surface talk." She went on to state that since teenagers' values are so far removed from those of their parents, the two sides have no common ground for discussing anything deeper than the weather or what's on the dinner menu.

Is Barbara right? Well, that depends. By "values," do you mean such things as which movies you see, the music you enjoy, or the way you like to spend your free time? Or do you mean where you stand on specific issues: abortion, the use of alcohol, or church attendance, for example. Or are you referring to whether or not you accept and generally adhere to the laws of God?

It is possible for parent and teen to seem to have differences of opinion on almost everything, yet to have basically the same value system. Mom, your daughter's sense of morals might be much more in line with your own than either of you realize. If you were to follow Barbara's advice and steer clear of any areas in which there might be conflict, how would you ever know where the other stands? Even more, how could you hope to have any input into your daughter's values and morals?

The main thing, Mom, is understanding exactly what is causing your concern. Is it "typical" teenage behavior—especially things today's kids do differently than you did when you were their age? Set those specific objections aside periodically. Concentrate instead on basic values—the difference between right and wrong; thinking of the other person rather than just oneself; adhering to such principles as loyalty, honesty, and responsibility; accepting the reality of God's purpose. Most of all, teach your daughter that God's law is the basis of your value system. Styles and ideas and philosophies and socially accepted behaviors come and go, but God's law is unchanging.

Also understand that life's choices are not all black or white issues. Learning to differentiate between our own prejudices and God's absolutes can be tough. God gave us some basic commandments—but we keep adjusting them and adding more. If we try to force our own particular values when we can neither give reasons for them nor base them on Scripture, our kids aren't going to listen very long.

Granted, in our society the biblical perspective on values and morals is a minority view. And, without a

doubt, our daughters are under great pressure to con-
form to the values of their peers and their world. Still,
one of the best gifts we can give our children is a
positive, healthy set of values and moral guidelines
based on God's laws.

Mom, short of locking your daughter in her room
with bars on the windows—and the television, radio,
and telephone disconnected—there are limits to the
influence you can have over her. You can't keep out the
world, but by talking openly about values, feelings, and
opinions, you will at least earn a right to be heard.

• **Daughter...** •

One of my church's youth directors was giving us a
lesson on dating and sex when the general question of
morals came up. He had two answers for us on how to
determine right from wrong: "When you are wondering
what to do," he said, "first consider yourself. If it seems
at all wrong to you, don't do it! Also consider others. If
what you are planning to do could cause someone else
to stumble or be hurt, don't do it!"

I think this is very sound advice in almost any situa-
tion. If I ask myself these questions before making any
moral decision, I can usually keep from hurting myself
and others, too.

It isn't always easy to know what is okay for others,
though. Morals can vary greatly from person to person
and from age to age. My mom has often told me that
when she was a teenager, in her church it was consid-

ered a sin to dance or to see a movie. Wow! I wouldn't even think twice about going to the movies or dancing. It's possible that I might offend my grandparents a little by going dancing, but not much.

Other values, however, have not really changed. When my mother was young, it was considered wrong by our religion and most of society to have sex before marriage. That's the same today and will probably be that way in my children's time. It is definitely wrong by my pastor's set of standards. Most importantly, it is wrong by God's standards, the most inflexible of all. Because I believe premarital sex is wrong, and I know the consequences it carries, I don't do it. Others whose opinions I respect also think it's wrong—another reason for my remaining chaste.

In the age we live in now, with so many different sets of beliefs and morals, it is often hard to determine right from wrong. All we can do is try to think over moral issues from our point of view and also from others', then recheck and measure our decision against God's law as presented in the Bible.

• We Can Work It Out •

Now that your daughter is no longer a child, it is especially important in discussing moral principles that you treat her views as respectfully as you would those of an adult friend. For instance, if a friend stated a particular position with which you disagreed, would you be more likely to say, "That's a dumb way to look

at it," or "I see it differently"? If she asked you why you feel the way you do, would you say, "Because I said so," or would you try to explain your reasoning? Your teenager is entitled to the same consideration and courtesy.

Discuss your standards and values. That means both sharing and listening. How do you each feel about the use of alcohol and drugs? About premarital sex? How important is honesty? How does the Golden Rule influence your relationships with others? Do both of you agree on what is meant by "values" and "morals" and on the importance of God's directives in your lives?

Daughter, once you have determined which standards you will uphold, will you be able to maintain those standards when the pressure is on? Consider how you will do this and where you will go for support. Your mother? Your pastor? A friend?

23

Teens and the Church

• Mother... •

Picture this scenario.... You are a church-going family. You notice that your teenager's Sunday-morning grumblings and complainings are becoming more frequent, but you choose to ignore them. Then one day your teen comes right out and says it: "I don't want to go to church anymore." She tells you she has been thinking about it for some time and her mind is made up.

Whether or not this has already happened in your family, it is not very unusual. What should a parent do? Should you insist that she go? If she is still adamant, should you force her? If so, how?

Perhaps the place to start would be to try to determine why your daughter feels the way she does about church attendance. Is she simply pushing for more independence? (In their need to become their own per-

160

sons, many teenagers take issue over any matter about which their parents feel strongly or in areas where they think their parents are holding on too tight.) Is she reacting to something specific you are doing, such as quizzing her on the way home to be sure she really did listen to the sermon? Or does she have a legitimate gripe, perhaps that there are no other kids her age at church? Understanding the reason behind the rebellion can help you decide how to respond to it.

The key, Mom, is to preserve the respect, trust, and congeniality of your relationship with your daughter. If you have a knock-down, drag-out fight and batter that relationship with emotionally charged words and threats, whether or not your daughter goes to church is really immaterial. We should never make the mistake of putting our daughters in a position of having to prove to us that we really *don't* have much power over them.

It is important that we not let the very Christian values we cherish and want our daughters to accept— such as love, peace, joy, and patience—be destroyed in a bitter and pointless argument about church attendance. Even if you manage to drag a protesting daughter to services, you cannot force her to respond to God.

The time is soon coming, Mom, when you will no longer be able to make choices for your daughter. She will be off on her own and doing her own choosing. Insist on your minimum requirements, then back off and pray. The consistency of your Christian life will communicate more than forcing your daughter to be "spiritual."

• Daughter... •

Karen's family had always gone to church together on Sundays. But their church was small and had no youth group. So, as Karen and her brothers got older, they started attending our church, which was larger and had more activities. Although their parents weren't very happy about it, at first they didn't say much. After a while, though, they decided that the whole family should stick together, so Karen and her brothers had to go back to the smaller church.

I think Karen's parents were wrong in their decision. They were being selfish by not considering their children's needs. If they had wanted to be together, they could have moved as a family to the church that offered something for everyone.

It is good for families to go to church together. But what if some family members get little out of the church they attend? Should they be allowed to change churches? Many parents would probably answer with an automatic "No!" to this question. But think about it for a minute, Mom. Some churches have large active youth groups in which teens can have fun and meet other Christians their own age. Other churches are made up basically of the thirty-and-older-crowd, and have nothing for the youth but the often-irrelevant sermons and a five-member choir. Which church would *you* rather go to as a teenager?

If you want to keep your family together for church, Mom, please be sure that the church you choose has something for your kids. And, fellow teenagers, be sure you have a better reason for being obstinate about

church than trying to prove a point about your right to run your own life.

• We Can Work It Out •

Before starting your negotiations about church-related issues, spend some time determining just what the problem really is. Mom, let your daughter do the talking first, while you do the listening. Then present your views calmly and clearly.

Sometimes just knowing the basis of the problem will suggest a solution. If there are very few young people in your church, perhaps your daughter could attend the youth group at another church. Mom, if you are used to conducting sermon quizzes, once you understand that it's an issue of contention, you can back off gracefully.

If you agree that your daughter has a legitimate gripe, perhaps you can work together to come up with another option to regular church attendance. You might agree that she will attend with you every other Sunday, or once a month, or just in the evening. On the off Sundays, she might be willing to work on a personal Bible study or volunteer as a nursery helper.

It is amidst the teenage group that churches are most apt to lose members. It may be well to consider giving in to the special needs of your young person by finding a church where she, too, can grow, share, and enjoy. Of course, it is also important to keep in mind and point out to a young person that belonging to a church is a

give-and-take situation. While one might ask, "What does the church have to offer me?" there is also the question of "What have I got to offer the church?"

It's a good idea to listen to the counsel of others on this matter. They may be able to give you wise advice and share what has worked for them. In the end, you need to work together in your family unit to find your own solution. The right way can vary between families, or can change in the same family as different stages of life are reached.

24

Questioning Beliefs

• Mother... •

"How do you know our religion is right?" Lisa was thirteen when she first asked this question. In the years to come, she asked it again and again: "Laura is a Mormon and says her religion is the right one. Deanna is Jewish, and she says the same thing about her religion. And what about all the Muslims and Hindus and Buddhists? They can't all be right. So how can you be so sure ours is the only true religion?"

I knew the question well—and all the arguments and reasonings and worries. I had asked them all myself. Many adults wonder about the same thing, and many are critical about those who claim to know the one true way.

I can adjust to weird hairdos and fashions. In fact, I consider myself flexible about most things. I can bend

with the times and adjust my opinions and prejudices. But when it comes to pushing the limits of my religious beliefs and corresponding values, I cannot yield. They are too important. My beliefs are often incompatible with those of other religions, but I know mine are the right ones.

It is usually disappointing to realize that it is impossible for us to make our young people own our faith—no matter how right we believe it to be. It's a choice each person must make for herself, which means she has the option to reject it. Yet it is precisely here that many parents, myself included, tend to grab most desperately and hang on most tightly.

What parents must recognize is that adolescence is indeed a time of "disillusionment." Teenagers will naturally remove from their faith the blind idealisms of childhood. Consider, for instance, the teachings concerning the love and protection of God. No matter how carefully we explain the context in which this protection occurs, a certain amount of misunderstanding is sure to take place in a young child's mind. She almost certainly ends up thinking that while bad things may happen to other people, they will not happen to her— because God loves her and is taking care of her. That is about as much of the truth as she can understand during her early years.

As she reaches adolescence, her understanding is deepened and refined. Now she begins to understand more abstract ideas. Yes, God does love and protect her, but this doesn't mean nothing bad will *ever* happen to her. That was just an illusion, a fantasy. And so, on her way to a mature Christian faith, she must

become "disillusioned" while she faces some bitter-sweet realities.

In order to arrive at her own value system, Mom, your daughter has to question and challenge and sift through yours. She will rarely assume that anything is true until she has tested it for herself. If you're like me, this is probably the hardest of challenges we moms face. We have to trust the parenting, nurturing, and teaching we have already done. And no matter how it looks, take heart if she seems to drift away. Most likely your daughter will come back. And when she does, it will be with a faith that is hers alone and perhaps even stronger than yours.

• Daughter... •

I always felt guilty when I found myself having doubts about my Christian faith. But now I know it's okay for me to have questions, although a few of them have no totally satisfying or cut-and-dried answer.

I've had so many questions. If God loves us so much, why is there so much pain and hardship in the world? How do I know that my religion is right and all the others in the world are wrong? If I've never seen God, how can I be sure that he exists? When my questions were given answers like, "God's perfect plan for us is a mystery, so we shouldn't even try to explain it," I ended up more confused than ever. I felt as if I was the only one who had any doubts.

It wasn't until I was talking to some of my friends at church that I realized that they all had doubts, too.

Some of their questions were the same as mine. When we went to our youth pastor for answers, he told us straight off that just about all the information we needed was in the Bible. With only a few verses, he straightened us out in several areas.

It's natural to have questions. Only very gullible people accept everything they are told. I learned that instead of feeling guilty about my doubts, I should do something about them. It would be wrong for me to have questions and not look for the answers. It's been so helpful to know older, wiser people in church who can answer questions, people other than parents. For me it was the high-school sponsors, the choir director, and a very special Bible-study leader.

• We Can Work It Out •

Mom, do you remember how your faith finally became personally meaningful? Why not share the circumstances with your daughter? It will encourage her to know that you, too, struggled and questioned. Let your daughter know you are available to answer her questions—without criticism and without judgment. And let her know you care enough to pray for her "without ceasing."

Daughter, if you find it hard to understand why your searching and questioning so concerns your mom, ask her about it. Don't just assume it means she wants to control you. She probably wants only to help you find your own answers.

25

Actions Speak Loudly

• Mother... •

Our Sunday-school class, made up of parents of teen-agers, had invited a panel of six teens to discuss with us the topic of the day—communication. "Of all things parents do," one mother asked the young people, "what bothers you the most?"

The kids had an immediate and unanimous answer: "When they tell us one thing, but do another."

"They think we don't know how to behave," one girl continued. "But we do, especially when they have set the right example."

So many young people today are unable to find any sense of meaning and purpose in their lives. Though few might admit it, they are crying for their parents to provide them with an ethical and moral value system

to guide them. They want the adults close to them to be models of integrity and character, to be consistent in what they preach and do.

But, Mom, before you can offer your daughter a proper and consistent direction to follow, you must find a direction for yourself—a foundation on which to base your own life. Whatever you profess to your daughter must be demonstrated by your actions. Only then is she likely to embrace the guidelines you set.

"My kids can't accuse me of being a hypocrite," one mom stated. "I don't 'preach' at all. My approach is to let them make their own moral and religious decisions."

That mother is either copping out or woefully ignorant of the world in which her kids are growing up. If parents don't teach their children about ethical, moral, and spiritual matters, who will? There *are* answers to life's conflicts and seeming contradictions, and kids need their parents to give them a stable grounding in what is right and what is wrong. The spiritual truths learned in church can best be exemplified in the family environment.

Besides providing an example that is consistent with your words, Mom, there are some specific ideas you can adopt to prepare your teenager spiritually. The first step is to recognize that spiritual instruction involves more than teaching your daughter "Christian facts." Be sure she knows that God has commands and desires for us. Then teach her how God has provided her with the ability to apply those commands in her everyday life.

An excellent way to help your daughter experience walking with God is to share your own spiritual life

with her—your relationship with God, your reliance on him, how you seek his guidance and help. Tell her about your answered prayers and the wisdom you have found in his Word. Share these with her as they happen. This way she will have the distinct advantage of "on-the-job training."

Remember to be an example of forgiveness. This means you must be forgiving toward others, of course. It also means that when *you* make a mistake, especially one that hurts your daughter, admit it. Then apologize and ask her forgiveness.

• Daughter... •

Why is it that parents always seem to have one set of rules for us and another for themselves? They say they don't, but their actions say otherwise.

My mom always wanted me to participate in everything our church offered for teenagers. I wanted to go to some activities but not all. For instance, by the time I was a junior, our Wednesday-night program had gotten old to me. I had more important things to do with my time. Yet, when I didn't go, my mom always said, "They have the program for you, so you should be a part of it." The ironic thing was, my parents didn't always go to the things the church had for *them* on Wednesday nights. If it was something that interested them, they went. If not, they stayed home.

The "spiritual" lessons that made the most impression on me were certain things I saw my parents do. For

example, when I was in junior high, my father was out
of work for a whole year. That was a really hard time for
all of us. But I remember so well how we all prayed
together and how we read the Book of Job, which al-
ways seemed to fit into our situation. (The week we
finished it, my dad got four job offers!) And I remember
how my parents told my brother and me over and over
that we had to depend on the Lord, and it really meant
something to us because we could see they were plac-
ing their trust in him, too.

The thing is, it's pretty hard for us kids to pay all that
much attention to what you parents tell us if you can't
even live by your own advice. But when we see you
living what you say, it's pretty hard for us *not* to
accept it.

• We Can Work It Out •

Any discussion about setting a good example should
begin with the basic understanding that parents, being
human, are not perfect. However dedicated and consci-
entious, no mother can be totally consistent in those
qualities all the time. The same is true of teenagers.

Daughter, if inconsistencies between what your
mom says and what she does are causing you problems,
tell her about it—in a non-accusatory way, of course.
Explain that it would make it easier for you to follow
the rules if you felt there were no double standards.

Mom, if your daughter comes to you about inconsis-
tencies, hear her out. Even though you will want to

defend yourself, to explain, maybe even to argue, listen to what she has to say. If the criticism is justified, try harder to practice what you preach. Also encourage other Christian adults to be available to your daughter. Not only can they serve as additional role models, but they will give her another sounding board and be able to provide a different perspective.